IMAGES
of America

NINE MILE
CANYON

Canyon Enchantment
Norma R. Dalton

Nine Mile Canyon's magic is discovering her creation.
 Living water, carving eastward, slashed the West Tavaputs Plateau.
 A trickle begins her birth, sculpting the canyon,
 Intertwining with two sister streams, Minnie Maud and Argyle.
 Eons of meandering, flooding, eroding, forever changing,
 Flowing sixty miles before mating with the great Green River.

 She celebrates life with radiant red earth,
 Green spruce, fir and lacy aspen.
 Kaleidoscopic motion rolls red to brown, golden tan to white.
 Evergreen becomes sage foam, canary yellow rabbit brush,
 Pinon, juniper and spiny greasewood.

 Unpretentious cliffs break through; rise to meet the azure sky, rebelling,
 Resisting, yet yielding to soothing, singing water song.
 Deeper in time, brown ledges become ribbons,
 Turquoise, purple, emerald, resplendent rainbows.
 Rock walls rise majestically, over a thousand feet,
 Curving, glimmering, facing relentless sun and wind.

Mysteries lie in her side canyons, twisting, hiding and disclosing.
 They vibrate with woman-like scream of lion challenge, and howl of coyote.
 Their names make statements of truth and reality. Blind Canyon ends.
 Is it fantasy that Dry Canyon runs water and Water Canyon is dry?
 Cow Canyon, a veranda for early homesteading is spacious and commanding.
 Desert facade of Houskeeper Draw belies stands of Douglas Fir
 Used for cabin building, corrals and derrick pole.

 Brown slates beckoned ancient artists who
 Chipped messages lasting over a thousand years.
 They thrived here. Settlers grubbed greasewood and sage,
 Built cabins of log and stone.
 Twice life abounded here, communities lived.
 Now they are gone, vanished.

ON THE COVER: This rock house was the homestead cabin of the Rabbit Ranch around 1883. It lies below the Cottonwood Canyon, site of the most famous petroglyph panel. It is on private ground; however, it can be viewed from the Carbon County road. (Courtesy Dalton/Rich family collection.)

IMAGES
of America

NINE MILE
CANYON

Norma R. Dalton and Alene Dalton

ARCADIA
PUBLISHING

Published by Arcadia Publishing
Charleston, South Carolina

Printed in the United States of America

Library of Congress Control Number: 2013952054

For all general information, please contact Arcadia Publishing:
Telephone 843-853-2070
Fax 843-853-0044
E-mail sales@arcadiapublishing.com
For customer service and orders:
Toll-Free 1-888-313-2665

Visit us on the Internet at www.arcadiapublishing.com

To my family, friends, and those who teach me.
To all who encourage and lift me, I thank you.
To the Creator of this forever-changing world that
supports, blesses, and curses us in infinite wisdom,
allowing these inhabitants to grow, understand, and
treasure this world and its natural wonders.

CONTENTS

ACKNOWLEDGMENTS

Those who helped me with the book are numerous. It's more daunting to try to name those I would like to than it was to do the book! First, I wish to thank my husband, who brought into our marriage a camera. For 65 years, we have been able to take pictures of our family, where we go, and what we do. Granted, many of those memories were hunting trips, since those were our vacations when and after we lived in the canyon. During this process of doing a pictorial, he has hunted through hundreds of albums and slides that he had put on the computer for images I needed. All images in this book are from the Dalton/Rich collections unless otherwise noted.

Next, thanks to our daughter, Alene, who is handy with the computer and as a critiquer. Sometimes I try her patience, but she has been steadfast in helping me with many projects. This book is the most recent. All of our children helped with photography. Our grandchildren have given me electronics and try to teach me to use them, "to help with my writing." Our daughters are Lorena, Winette, Alene, and Cami. Thank you.

Our son Keven services our computer and equipment. If he got paid for what he does for us, he'd be rich. Our son Wayne gives us financial help and encourages us through our projects.

My siblings gave me access to our family albums, as much and for as long as I needed them. Without our mother's diligence in saving our family photographs over 70 years, I could not have documented this book.

My two cowboy historians are my brother Bus Rich and dear friend Ben Mead. To my question "What do you know about . . . " they always have the answer. My critiquing writer friends are Marge Holt and Joann Weaver. They are steadfast and dependable.

I asked Dr. Pam Miller, Margene Hackney, and Jim Felton to prepare a report on their organization's activity in the canyon. All were gracious in doing that. Thank you.

The Nine Mile Canyon Settlers Association, organized in 2004, consists of, as directors, my brothers, Bus and Kirt Rich, and sister, Evelyn Oldham, their spouses, my husband, and all our children. All these have supported and sponsored this project.

Nine Mile Canyon has no street signs. It has taken memories of many to help me properly gather the names of side canyons that come to the bottom of Nine Mile Canyon. Those who live or have lived in Nine Mile Canyon use these names for conversational reference.

To all who encourage me, thank you, I love you all.

INTRODUCTION

This pictorial of Nine Mile Canyon begins with the history of the Nine Mile Road. Early settlers along the Wasatch Front were searching the country around looking for prize areas to graze their livestock and raise crops. Early explorers found good grazing in the heads of Argyle, Minnie Maud, and Nine Mile Canyons. These canyons are valuable because each has a live (continuous) stream of water year-round.

Nine Mile Canyon Creek begins in the watershed on the summit and continues to Green River, a distance of nearly 60 miles. It is the main stream. The Minnie Maud Creek enters Nine Mile Creek first from the north side a few miles below the summit. Next, about 10 miles below this junction, the Argyle Creek joins the first two.

Water erosion in this desert country created a deep wondrous canyon with high country of evergreens and quaking aspen trees. The north-facing draws support canyon builders with spruce and fir. On the other side, facing south, fortress-like walls of explosive ledges, burned by sun, water, and wind, provided large dark panels for the ancient people to etch their thoughts and information.

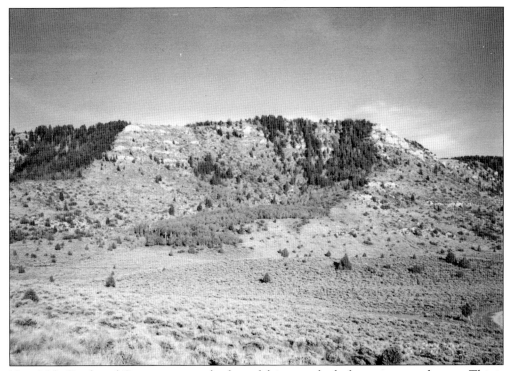

Nine Mile Creek and Canyon start at the foot of this watershed of evergreens and aspen. This is the summit, the highest point of the canyon. The terrain drops sharply in altitude and erosion rips into the earth.

7

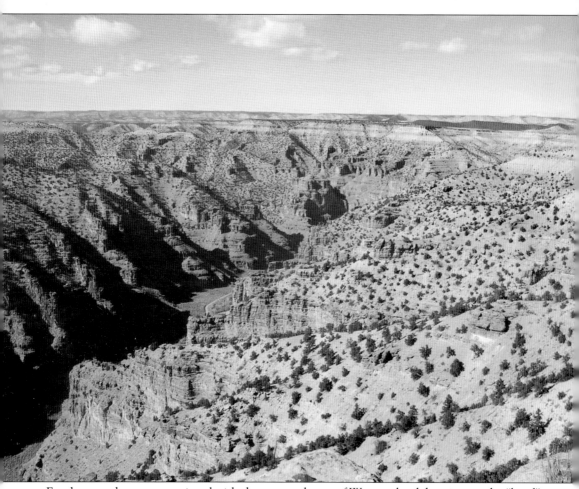

For those readers not acquainted with the nomenclature of Western land description, the "head" of a canyon is the highest point in altitude, where a ravine cuts through to erode a deep crevice into the earth. In the Western landscape, layers of formations are often exposed to create colorful and interesting landforms. If one traveled down one of these canyons, he would see that it opens up or fans out when reaching the bottom. This "fan" is referenced as the "mouth" of the canyon, as the canyon ends when it loses its eroding power. Each canyon has an up or down. When there is a rise of elevation, we say "up the canyon," and when dropping in elevation, we say "down the canyon." The name "Nine Mile Road" replaced the early pioneer names used before the settlers and military created a more defined route of travel from the Emery County Basin—later the Carbon County Basin—to the Uintah Basin. Above is an image of the side canyons coming toward the bottom of Nine Mile Canyon. From both sides of the main canyon, these eroded crevices spiked through ledges, sometimes leaving a passable trail for stock and a rider on horseback, but most are not open to travel and are referred to as blind canyons. Some ranchers used dynamite and blasted trails through.

One

NINE MILE ROAD
TO SHEEP CANYON

On the west side of Price, Utah, freighters through Nine Mile Canyon developed a stopover to disperse their freight and get a new load. The Freighter's Park was near the Price River. The railroad came to Price in 1883. At this time, freighting picked up considerably. Prior to the military occupation in the Uintah Basin in 1886, only pioneer supplies were freighted back and forth over the Nine Mile Road. During those early settlement times, few families had set up homesteading along the Nine Mile Canyon creek. Cattleman built temporary cabins while grazing their cattle and later sheep in the heads of Nine Mile, Minnie Maud, and Argyle Creeks. The makeshift road was actually called the Minnie Maud Road. It followed an Indian trail most of the way from the Uintah Basin until it dropped down Soldier Canyon from the Nine Mile Canyon summit.

Leaving Price, the Nine Mile Road travels north to the foothills then east nearly 14 miles, finally arriving at the mouth of Soldier Creek Canyon, the first stage coach stop.

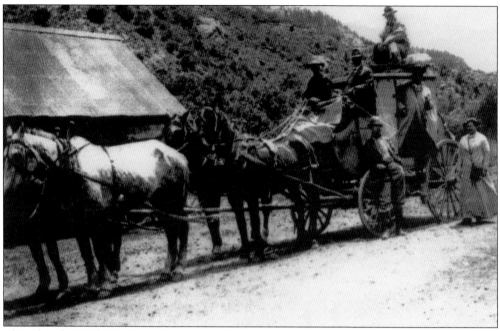

The Edwards Ranch in the mouth of Soldier Creek Canyon on the Nine Mile Road (considered part of Nine Mile Canyon by the people who lived there) furnished support to all who passed. This image shows the stagecoach picking up mail and supplies. (Courtesy Edwards family collection.)

The present-day road to Nine Mile Canyon leaves Price on Highway 6, travels a few miles east to Wellington, and then continues a few miles to the exit sign to the canyon. Soon after leaving Highway 6 and looking forward toward the West Tavaputs Plateau, a sign invites travelers to explore the canyon.

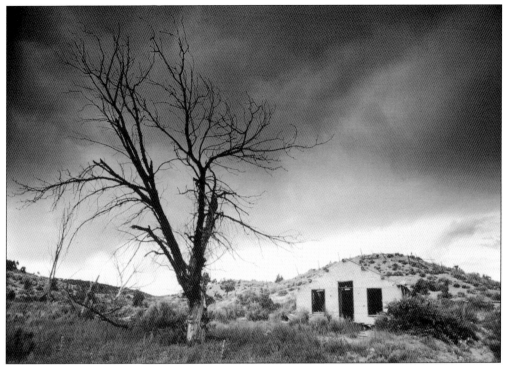

This is the homestead of Dave Anderson, who was very much involved in the lives of Nine Mile Canyon people. This cement dugout, which extended far back into the hillside, was home to Meril Mead and family from 1937 to 1938. This author remembers attending a dance of a few couples and one musician there in 1938.

Three miles beyond the Edwards Ranch, the Soldier Creek Mine comes into view. In pioneer days, before the mine was developed, an exposed vein of coal hung over the road, and a passerby could whack off a piece of coal to take home.

When reaching the top of Soldier Creek Canyon, the Nine Mile Road crosses the "Park," a broad band of open country of sage that is bordered on the south by timber and quaking aspen. On the west side, this open country continues for miles toward the Wasatch Front. There is a series of high foothills on the north. The Whitmore homestead cabin still stands here.

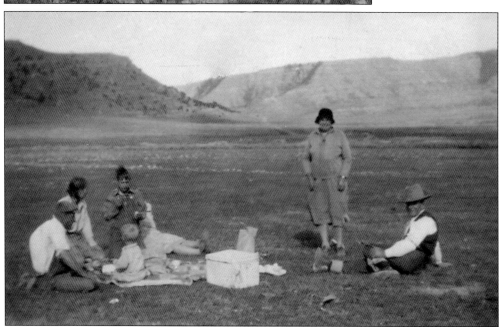

It was a relief to travelers, especially freighters, to finish the pull of Soldier Creek Canyon. In that canyon, a self-help blacksmith shop in a log cabin was outfitted with tools, a forge, tongs, and horseshoes for anyone that needed them. The users replaced these items when possible. East in the light part of image is the summit of Nine Mile Canyon. Pictured are Shorty and Helen Smith with their children, Minerva Hanks (standing), and Bill Gwithers (seated on the right).

Looking west up through the Park, this type of topography continues to the summit of Spanish Fork Canyon. Early explorers looking for livestock grazing areas came up Spanish Fork Canyon and discovered Nine Mile Canyon. This area is now named Whitmore Park for the Whitmore family, who relocated from Texas to Utah in 1857.

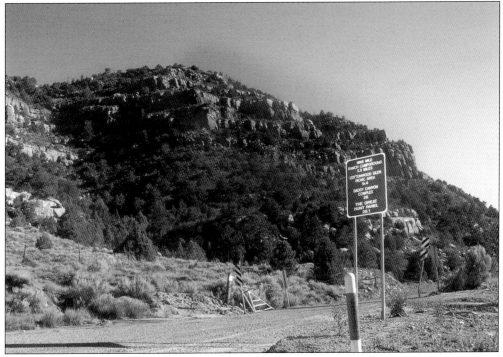

The summit and beginning of Nine Mile Canyon is seen here. This mileage sign lists points of interest in the canyon. The Nine Mile Road continues down the canyon.

13

Virgil Barney's family built a lumber home up in the quaking aspen above where this image was taken. This small shack was used to house their sawmill. It still stands on the south side of the road just below Indian Canyon, a small canyon on the north side.

The Nine Mile Creek makes an impressive cut through red banks a short way down from the summit, which is around 7,000 feet. About 20 miles down the canyon, the elevation drops to around 5,500 to 5,600 feet. It is much more difficult to get a dam built high enough to take water out on the level of the ground to be irrigated when the channel is so deep.

This peaceful camping site, called the Hollow, has been in use since travel on Nine Mile Road began. It is level and close to water and woods. It is a good place for travelers to rest their horses before the pull over the summit of Nine Mile Canyon if they are going west.

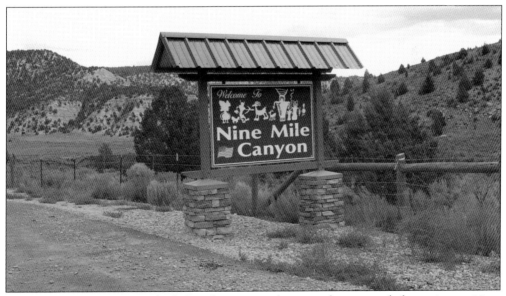

This attractive sign some miles below the summit alerts travelers to watch for ancient writings on smooth rock surfaces down the canyon.

Minnie Maud Creek comes from the northwest to join Nine Mile Canyon. Its waters enter the Nine Mile Creek just after they pass under the bridge. While this canyon is neither wide nor very deep, its head is timbered, and the earliest ranchers found it great for cattle grazing. Sparse farming claimed some of the canyon floor, but the mouth of the canyon widened out to accommodate good-sized fields. In settlement days, many productive gardens and crops were sold to freighters and travelers to bring in income for families. (Courtesy Diane Gorman Jenkins.)

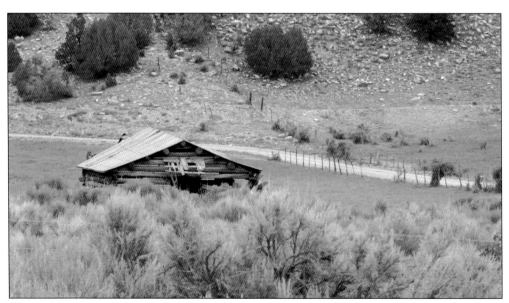

This cabin was built in the early 1880s. Many names are attached to this area. Hamilton, Christensen, Hall, and Bryner were some of the settlers here.

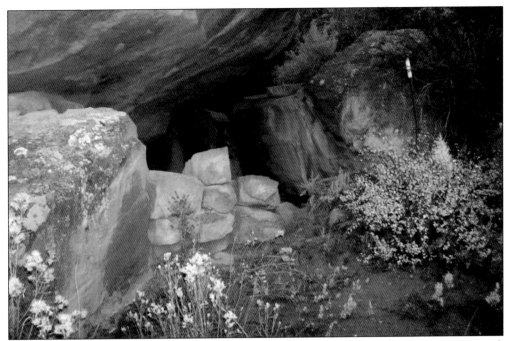

This is the part-time home of Myron Russell. He came to Minnie Maud with two brothers, never married, and lived his life following his small herd of cows. He had a packhorse to carry his tent and supplies while he grazed his cattle up in the high country where he had permits. When picking up his pension check from the mailman once a month, he would stay at his rock house under the boulder near Nine Mile Road. The rocked-up shelter, now eroded away, was weather tight with a bed, stove, and necessary commodities. He rode on horseback to town to visit folks and get supplies when needed.

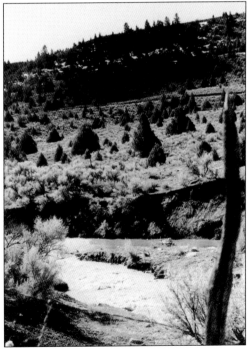

The two main tributaries to Nine Mile Creek are Minnie Maud and Argyle, both entering from the north side. Each has a beginning in a different stratum of soil. Nine Mile Creek runs red in high water or during flash floods, Minnie Maud runs black or dark gray in color, and Argyle runs pure white. Normally, all have clear water. This image shows Minnie Maud entering the red Nine Mile Creek after both have recently had heavy rains in their beginnings, causing a small flash flood.

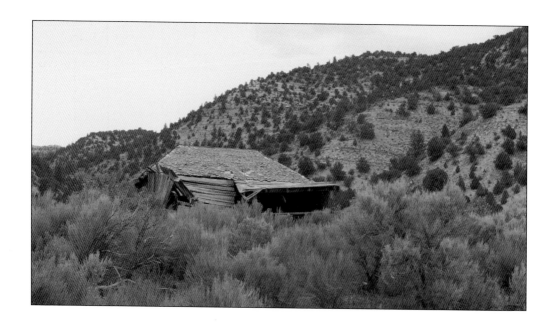

The old Russell Homestead cabin was moved in an attempt to relocate. It pulled apart and was abandoned. Its home is a half-mile farther down the canyon. The image below shows the site of the Russell Homestead.

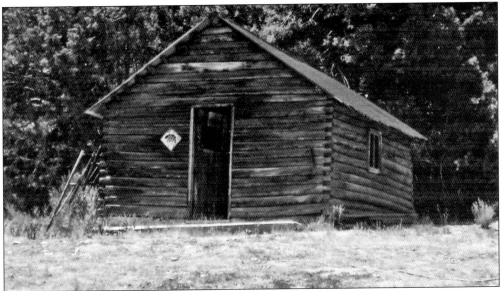

Clarence and Mary Barney married in 1897 in Kanosh, Utah, where their first two children, Virgil and Thursa, were born. They moved to a small farm in Ferron, Utah. Clarence went to work for Preston Nutter in Nine Mile Canyon to help support his family. He then homesteaded in Argyle Canyon in the cabin shown here. When the government survey of 1936 was completed, it showed the Barneys' cabin partly inside Arnold Shultues's property in Argyle. Arnold took over the cabin and all its contents. (Courtesy Houskeeper family collection.)

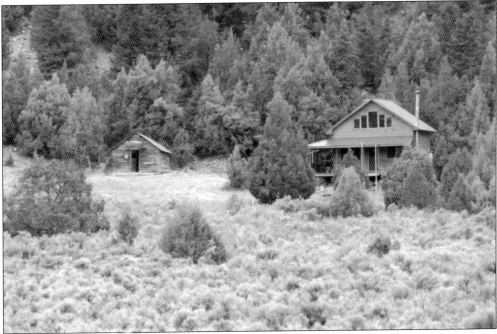

Clarence's son, Doyle, had property southwest of Sulphur Canyon; he took his wagon up to his parents' cabin, dismantled the cabin, and hauled it up to his property, taking all their possessions. He rebuilt it, and it still stands today. Some of their posterity have built a larger cabin near the old one to enjoy the surrounding area. (Courtesy Diane Gorman Jenkins.)

Sulphur Canyon—a small, narrow canyon that reaches high onto Argyle Ridge, where timbering is available—enters Nine Mile from the north. Ted Houskeeper cut poles for mine props during the 1950s and moved them to Carbon County Mines. Many different homesteaders have lived here since early 1880s. Nephi Smithsen's family lived here in 1900s in a home built of stone. This is the present cabin site. Notice the pyramid-shaped mountain. (Courtesy Craig Houskeeper.)

This is the mouth of Sulphur Canyon. In September 2007, a violent flash flood came down this canyon. It tore out the road and hit the bend into Nine Mile Creek with tremendous force. It tore out the cribbing and heavy logs of the Houskeeper/Alger Dam.

20

The boundary of Nine Mile Ranch begins in the mouth of Sulphur Canyon and is owned by the Mead family. They have a bed-and-breakfast and run a cattle ranch. The diversion dam for their irrigation was a huge project when it was built by hand in the late 1890s by the Alger brothers and the Houskeepers. This dam is the highest built in Nine Mile Canyon due to the rapid drop of elevation from the summit to this point. The man on the dam in the image below is Ted Houskeeper, grandson of homesteader Theodore F. Houskeeper and son of Theodore B. Houskeeper. (Both, courtesy Houskeeper family collection.)

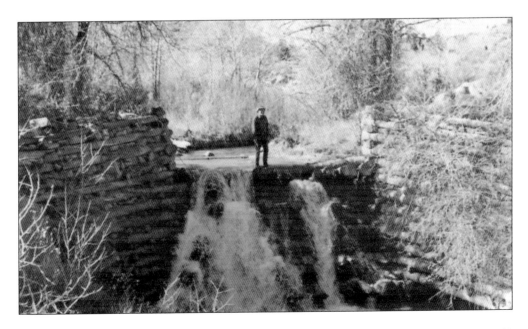

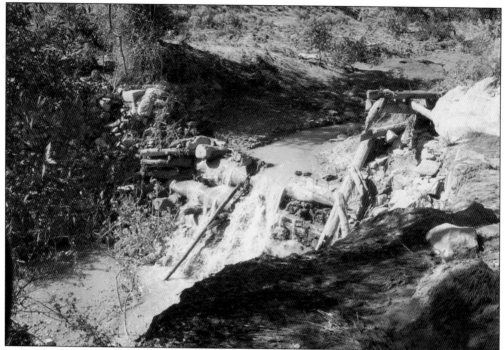

A tremendous flash flood in September 2007 whipped down Sulphur Canyon, rising 60 feet on the walls and blasting out of the mouth to flood over a large culvert in the road. It deposited a boulder on top of the culvert the size of a car. It ripped out the bank of the canyon as it turned down Nine Mile Creek and hit the dam, destroying the cribbing on both sides and taking some of the original logs. The Meads are still able to take their irrigation water out of this dam. It still is useful after being in place for over 110 years.

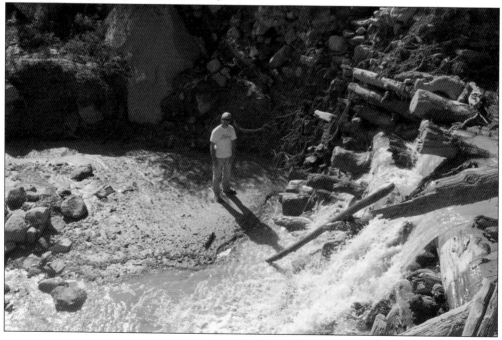

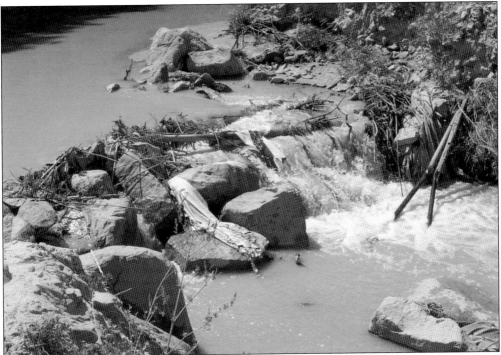

The Frank Alger Dam, about 10 miles down the canyon, is almost level with the fields that need irrigation. It only takes a few large rocks to turn the water into Alger's head gate. When flash floods tear out this dam, a few large boulders are needed to restore it.

This huge tree was deposited in the Meads' irrigation ditch just below the dam. Ben Mead salvaged it to use as his gatepost at the beginning of the turnout to his bed-and-breakfast, campground, and home.

In early September 2007, the Nine Mile Canyon Settlers Association held its annual rendezvous on the flat surface of an old oil rig pad. Plenty of brush grew here, and a clearing of grass provided a place for members to pitch their tents. Nine Mile Canyon Road can be seen near the camp. This place is about a half-mile below Sulphur Canyon; the small canyon is called Sulphur Draw. This campsite was used about a week after the previously mentioned flash flood from Sulphur that took out the dam.

About 36 hours after the Nine Mile Canyon Settlers Association campers left the above area, a big flood tore down this narrow canyon and swept over the campsite, ripping off the vegetation and depositing a foot of mud, rocks, and logs on the site.

Ellen Mead was married in April 1928 to Meril Mead, who had leased a ranch in Nine Mile Canyon and was a permanent resident. Meril brought Ellen home from the Price, Utah, area on a wagon loaded with her belongings in the chilly spring. She marveled at the change in the scenery mile after slow mile. Upon viewing this mountain above the present Mead Ranch, she exclaimed, "Look at the loaf mountain," explaining to her new husband, "It looks like a cut loaf of bread." The name stuck.

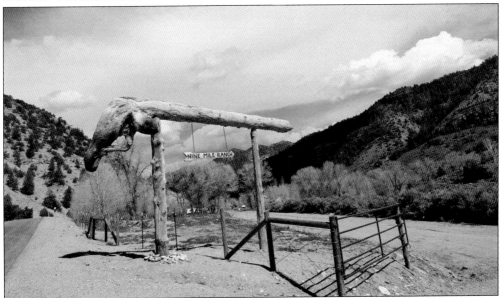

This gate is over the Nine Mile Ranch bed-and-breakfast, campground, and home of the Mead family.

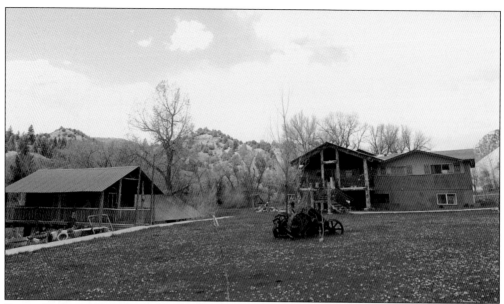

Ben and Myrna Mead are the Nine Mile Canyon historians. They strive to restore the old cabins when they become available. At the present time, they are finishing their third cabin, which will be available for guests to come for a visit. The location is in the vicinity of Spring Canyon on the south and Loaf Mountain on the north. This image shows their home with an old Houskeeper tractor in the yard and a cabin over a pavilion built on the left side. The pavilion has restrooms and a cooking/serving place for groups visiting the ranch.

The three restored cabins belonged to original settlers; on the left is the Glen Edwards Cabin, in the middle is the Houskeeper Cabin, and on the right is the Al Thompson Cabin. The Meads' Nine Mile Ranch is at the west end of the most generous piece of landmass available for irrigation and fields, in the mouth of the canyon named Cow Canyon. Below the Meads' property lies the original homestead of the Houskeeper family.

Below the Mead Ranch lies the property of the Houskeeper Homestead. This image is looking down Cow Canyon on the north side of the creek, which is on the right side of the image. The cabin, now gone, has had its remains restored on the Mead Ranch. (The Houskeeper history is one of many histories of early Nine Mile Settlers being preserved by the Nine Mile Canyon Settlers Association.)

Theodore F. Houskeeper was born in Philadelphia, Pennsylvania, in June 1843 and died in January 1915 in Utah. On the left is Sarah Butler, who was born in Redbourn, England, in May 1842 and died in February 1920. Both are buried in Orangeville, Emery County, Utah. Their nine children were born in the Payson, Utah, area and raised in Nine Mile Canyon. They learned about the canyon from neighbors and cleared land for their homestead.

A son of Theodore F. and Sarah, Theodore B. Houskeeper married Clarissa Alger, and together they raised their five children in the canyon. Clarissa and two daughters were traveling to Price, Utah, when she was killed in a runaway buggy in Soldier Creek Canyon. This tragedy broke up the family. Theodore leased out the ranch and spent the rest of his life herding sheep.

Theodore B.'s son Theodore, "Ted," farmed and raised cattle until the ranch was sold in 1962 to the Hammerschmid family, who owns it presently. Ted and Kay Christensen Houskeeper lived on this ranch and raised their five children, moving into town during the school year.

This image shows the immense area opened up for cultivation on the south side of the creek. Many homesteaders cleared small plots of ground, sold out, and moved on. Cow Canyon was visited by many, beginning with farmers and ranchers. Among those were Charles Smith, the Babcotts, the Alger brothers, Lisonbee, and Thompson. Cow Canyon runs a live stream year-round; irrigating is easy on that side of the creek.

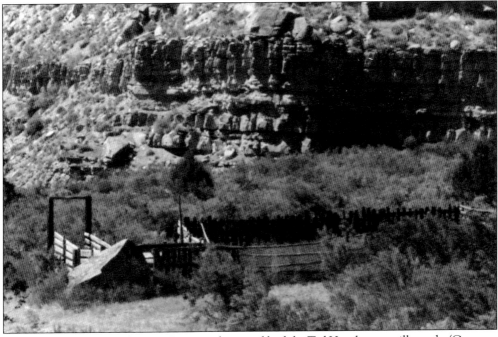

Near the end of the Houskeeper Homestead, a corral built by Ted Houskeeper still stands. (Courtesy Houskeeper family collection.)

Below the Houskeeper Homestead is Kimball Canyon, coming from the north. The canyon has a steep trail used by ranchers to move cattle and horses up to the bench area for summer grazing.

Shown here are rows of rocks that were originally used for the foundation of a schoolhouse in the mouth of Kimball Canyon. Schoolchildren from Minnie Maud to Sheep Canyon attended here.

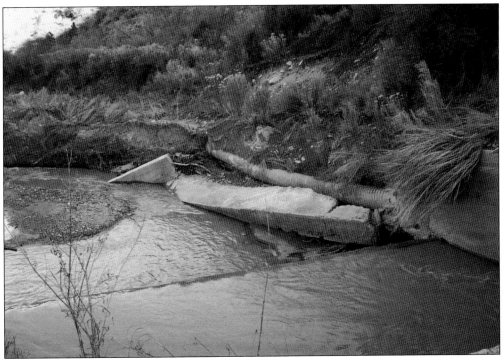

There were three concrete dams built in the canyon. This one is at the mouth of Kimball Canyon. The drop in elevation was great and the water had to be run through a culvert underground on a grade to finally reach the south-side surface of Sand Flat Field for irrigation. This diversion site carried water down Nine Mile Creek to the original homestead of Don Johnstun and his son, Sam. It watered land on both sides of the creek. When necessary, the water was moved from one side to the other by building a flume, usually of wood or, as is more common now, pipe.

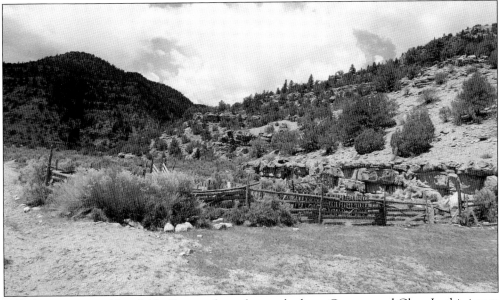

Bills Canyon enters Nine Mile Canyon from the north above Cottonwood Glen. In this image are the corrals used by homesteader Don Johnstun in the 1910s.

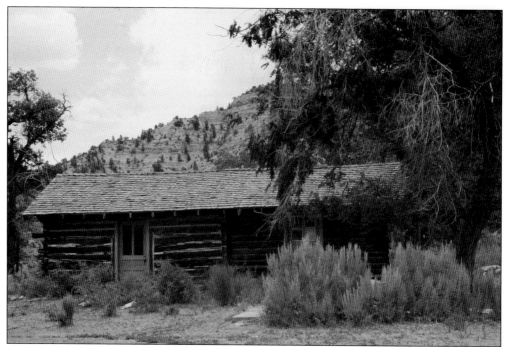

This property changed hands many times after homesteader Don Johnstun and his family settled here around 1896. Some of the owners were Bill Lines, Doyle Barney, and Tom Christensen, who lived here during the 1940s and 1950s. This log home is the second one on the property of the Johnstun family. Their first log home burned, leaving only a stone chimney. A dugout cellar used to store the family's root crops is nearby.

When in good condition, the Johnstuns' barn housed hay and grain crops. A different feature of this barn were the dutch doors at the front and back entrances. The top half of the door opened separate from the bottom half. An orchard grew between the house and barn.

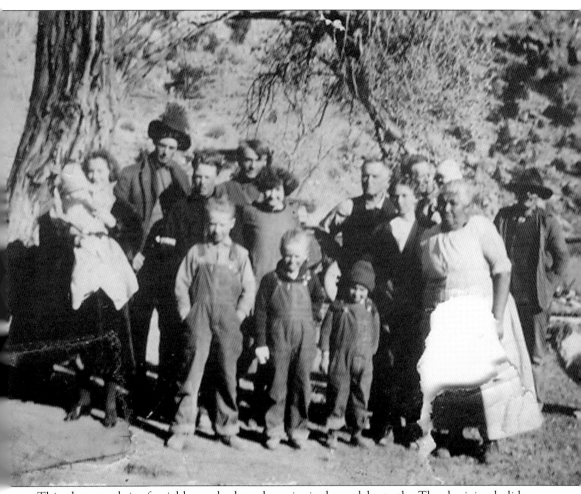

This photograph is of neighbors who have been invited to celebrate the Thanksgiving holiday in November 1925 by the Johnstuns. The second row in the image includes, from left to right, Crystal Thompson Barney holding her son, Gale; Virgil Barney in the black hat; Arbun Rich; Myron Russell; Pearl Rich; Charles C. Rich and his wife, Theadocia; and an unidentified man with a baby, who might be a Johnstun. On the right side in a dark hat is Al Thompson. The first row shows Charles and Theadocia's four sons, from left to right, Thorald "Cotton," Dave, Art, and Ken (in the shadow). On the end is Martha Brown, an Indian woman who lived many years with the Johnstun family. Martha Brown has an interesting history. She was a young Piute child when, during an Indian skirmish between two tribes, her parents were killed and she was taken captive; years later, the Indians were traveling past the Johnstun home and offered to sell Martha. Mr. Johnstun purchased her with a heifer. Martha was an excellent cook and hired out to ranchers in Nine Mile Canyon. She cooked for Frank Alger and the Harper stage stop. She was known for her excellent apple pies. She married briefly, to a drifter, and soon returned to the Johnstun family, who had raised her as their daughter.

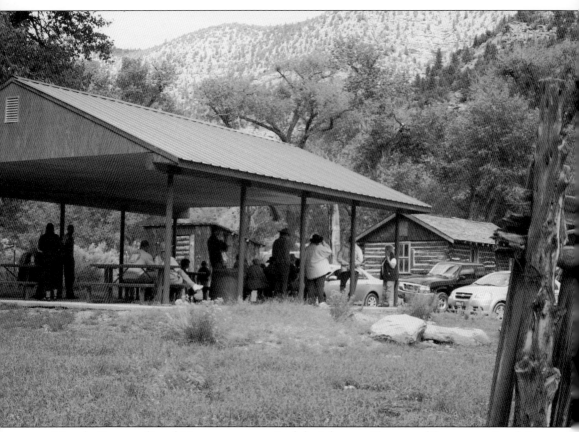

After the Bureau of Land Management acquired the Johnstun Homestead for a recreational site, the Carbon County Travel Region raised funds to build this convenient bowery for use of visitors to the canyon. Carbon County maintains the area.

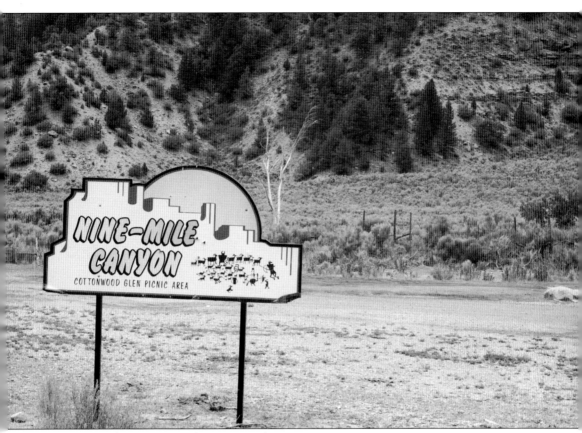

This sign is at the Cottonwood Recreational Area.

Just below Cottonwood Glen from the north is Lion Canyon, so named by the children in Charles Rich's family, who traded their homestead in the Roosevelt area for this one in Nine Mile Canyon in 1923. Theadocia Rich, Charles's wife, was very much opposed to the trade, and after a few years, the ranch was turned over to their oldest son, Jerry, and his wife, Wanda, who raised their family on the ranch.

This is the homestead cabin on the Rich land as seen today. Lion Canyon, just above the corrals, was the scene of many deer kills by lions. The Rich children scouted them out following a night of terrifying lion screams.

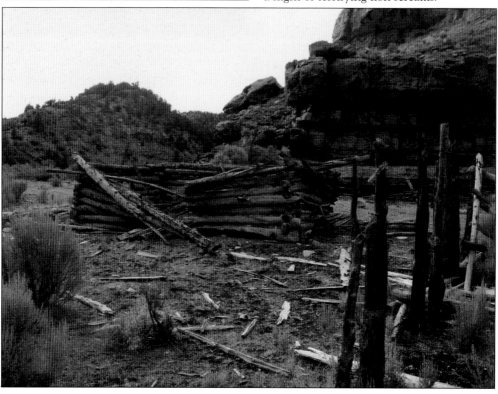

Sheep Canyon enters Nine Mile from the south. It had a well-used trail for putting animals up on the summer range. Sheep Canyon trail entered Dip 'n Vat by Big Mountain, then joined the Granny Canyon Trail at Bill Gwyther's rangeland cabin near a spring in the east fork of Sheep Canyon.

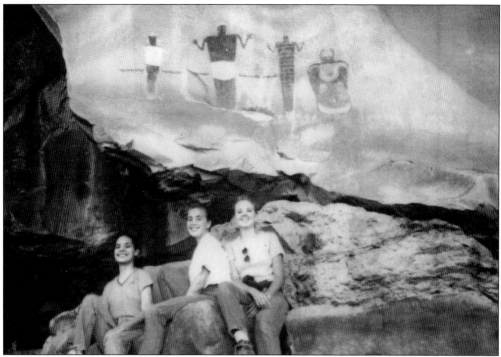

Looking up Sheep Canyon, visitors parked with binoculars may view a lovely pictograph on the left side of the canyon on the mountain bottom in a ledge just before the large arrow indicating a sharp turn. It features three maidens and an old man in red, white, and black pigment. Pictured are Laura Dalton (center) and friends.

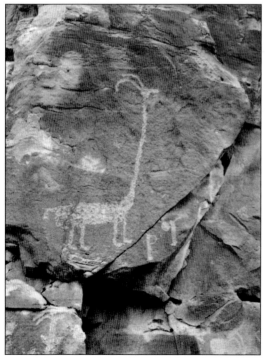

A seldom seen but popular petroglyph in the canyon is dubbed the *Long-Necked Sheep*, though some children see it clearly as a giraffe. If a visitor is stopped and looks north, a rather long, low appendage sticks out from the mountain. This is the cause of the sharp turn. On the end of this low mound is a small pit house. Following this small ridge up to the ledge, about 50 feet above the road, a visitor can follow the base of the ledge (left) or to the west and see many petroglyphs the full length of the ledge. This long-necked sheep is on a small ledge below.

Continue down the road around the bend and look at the skyline. There appears to be a boat-shaped rock on the horizon. It is definitely sticking out above the line of the mountain. It is what canyon dwellers refer to as a lookout tower.

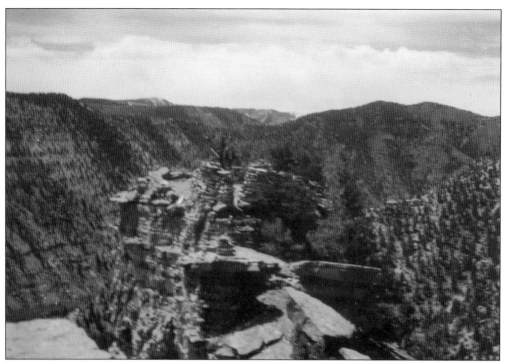

Pictured is the Sheep Canyon lookout tower.

These prehistoric dwellings, writings (petroglyphs), and paintings (pictographs) are titled *Fremont People Who Left Nine Mile around 800–1350 AD.*

40

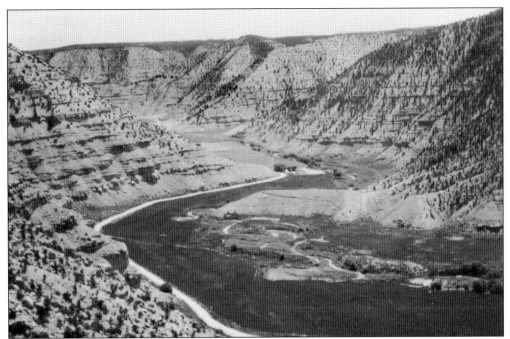

Beacon Ridge is the light, treeless appendage coming from the mountain on the south side of the creek. It has pit houses and other signs of occupation on top. However, to the right of Beacon, along the creek and a low hill, is a very large village of pit houses and living areas; these have been excavated by some professionals and dug out by potters or vandals. Sheep Canyon had lots of pottery, rabbit-skin blankets, basketry, woven reed mats, granaries or storage pits, and even some burials. Now, these dwellings are history, all observed from the high lookouts on the skyline.

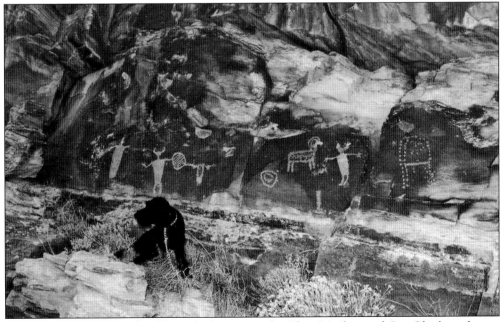

This is one of many panels of petroglyphs next to the *Three Maidens and One Chief* panel, seen on page 38.

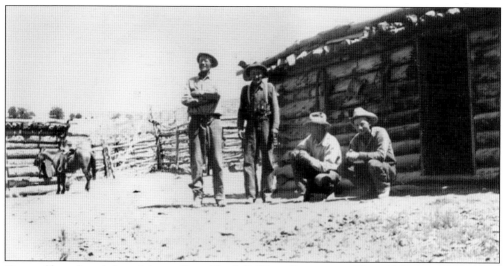

Pictured here from left to right are Dave Nordell, Oliver Rasmussen, Thorald Rich, and Humbert Pressett. Granny Canyon (below) opens to Nine Mile Creek and begins at Bill Gwyther's homestead cabin at the base of Big Mountain. These cowboys are enjoying lunch and a visit at Bill's cabin. Notice his saddle shed and corrals in this c. 1930 image.

Granny Canyon's mouth opens to Nine Mile Creek. There was a good trail here that led to the high country, where aspen and evergreens grow. It heads out at Bill Gwyther's homestead cabin, which has a good spring.

Two

HARPER TO GATE CANYON

Harper was the community center for a nearly 60-mile-long canyon. During the heyday of freighting through the canyon, it teemed with visitors coming and going. Add an active stage service connecting the Price area with the Uintah Basin and there were many interesting happenings.

After visiting the Sheep Canyon complex, the traveler passes Beacon Ridge and can see a barn and corrals nestled in a grove of cottonwood trees. Around the corner is the Harper Post Office, which was housed in a small cabin. Behind it is a bunkhouse for stagecoach drivers and other men needing an overnight stay. Then a very large 13-room hotel came into view, but this building was destroyed by fire.

The Ed Lee Complex included a very successful hotel during the freighter's use of the Nine Mile Road, beginning in 1886. The stagecoach business became popular soon after, creating a need for stops where the coach would receive a new team of horses that was rested and anxious to travel speedily. The Lee Ranch, a site with carefully planned corrals and barn, became a favorite stage stopover. The kitchen employed good cooks, and delicious meals were planned; plus, accommodations were available for travelers to rest and freshen up.

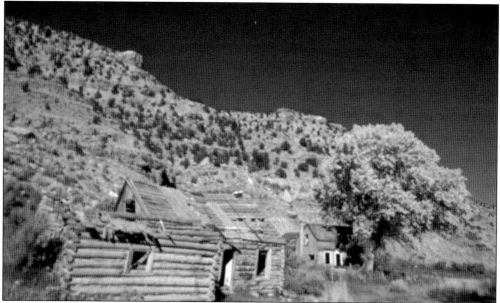

Mail has always been important to Nine Mile residents. When no service was available, residents picked up each other's mail and delivered it or sent word that they could pick it up. Sometimes, they shopped for each other, as the trip to Price by wagon could take two or three days each way. Mail was delivered to the Harper Post Office by stage from the Uintah Basin as well as Price, Utah. This continued until the canyon was serviced by motor vehicles.

The Alger brothers were contracted to build this barn at the stagecoach stop in Harper. The logs in the barn were squared with a broad ax or adz, even the inside supports in the barn. On the outside of the building, chinking was done with narrow pieces of lumber to keep the inside warm.

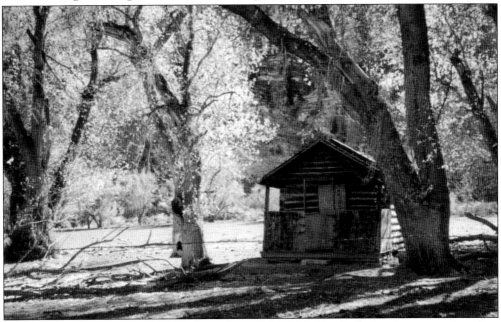

Rows of cottonwood were planted in front of the barn to give shade for the teams when they pulled the stage in. While the stable men changed out the teams, the driver and his companion, the shotgun rider, took a break and perhaps had a meal. This small house was moved from the spring on the Argyle property to this location by Russ Wimmer.

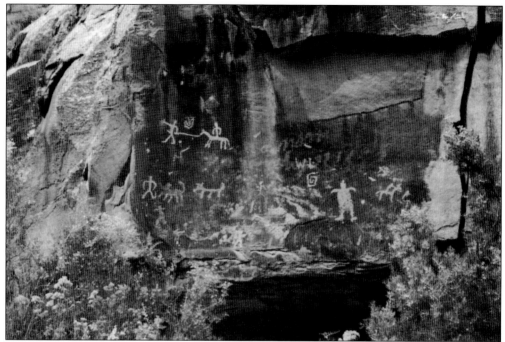

The Harper Complex sits in the middle of an archaeological site. Up on the knoll west of the house is a large circle of rocks that suggests a pit-house dwelling. Down the road past the buildings where the mountain comes to the edge of the road, there are many petroglyphs along the dark slates. Also, a large slab of rock has fallen down, forming a wedge behind the slanted rock. Seen here on the back side are many small, red pictographs. These have been here for nearly a thousand years.

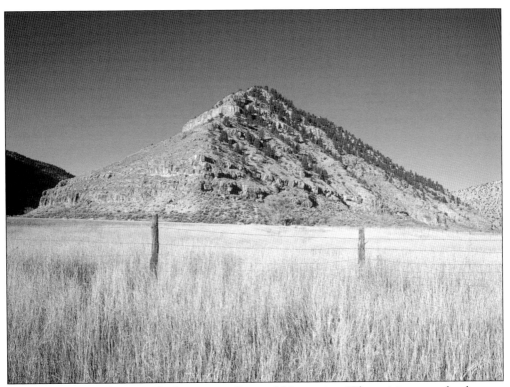

In the upper part of Nine Mile Canyon are Pyramid Mountains. When visitors pass by the spot to see it, the mountain seems to change shapes. Seen here are two that might be noticed. The image above is near the Argyle Canyon sign, slightly up the road. The one below is on the east side of Sheep Canyon. (Above, photograph by Brent Houskeeper.)

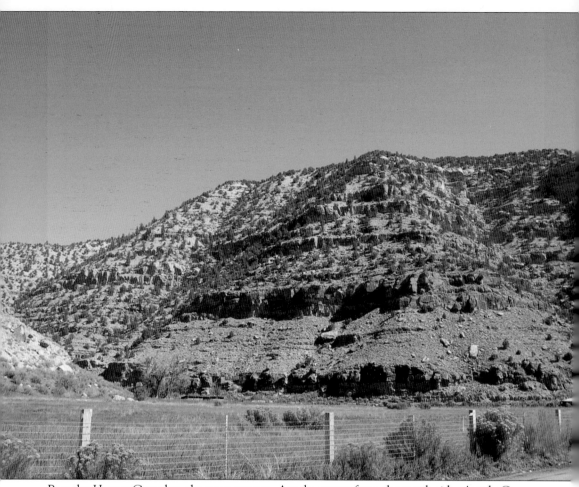

Past the Harper Complex, the next canyon, Argyle, enters from the north side. Argyle Canyon has a great history of settlers and unique canyons, and its creek joins Nine Mile Creek just below the bridge.

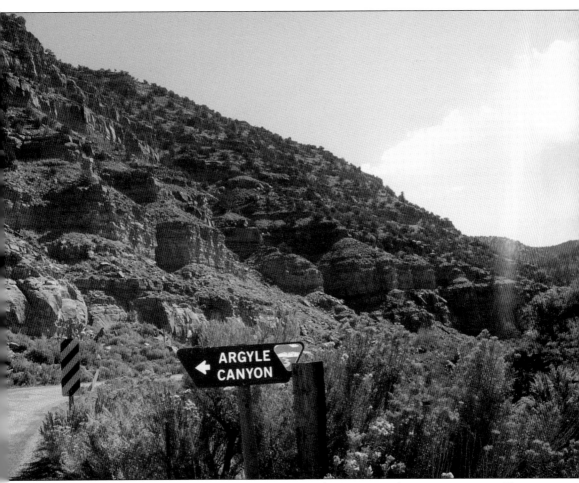

This sign indicates a road leading northwest up Argyle Canyon and continuing to join Emma Park Road, which tops out at the summit of Price Canyon. This land between Nine Mile Creek, Argyle Creek, and the mountain is a choice piece of property because there is a large spring against the mountain. The first settler cabins were built here. During the 1930s and 1940s, a large CCC camp was also built here.

The CCC built a springhouse over the spring to protect it from animals and made other improvements in the canyon. When they left the canyon, they gave one of their buildings to the canyon people, and Ted Houskeeper purchased two others. He moved one to the Houskeeper homestead area for his home and gave the other to residents for a school. In this image at the apex of this plot of land is a lovely log home built by the family of Neville Wimmer. It has since been sold.

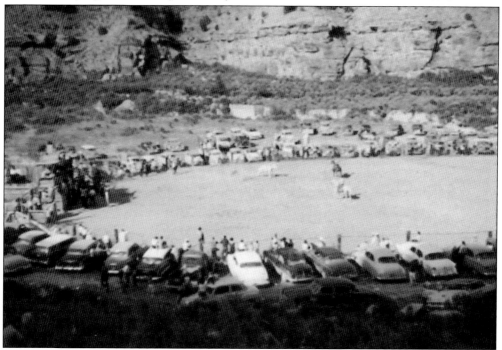

After the CCC camp left the canyon, the residents built a large arena for rodeos in the area that had been vacated in Argyle. This was a popular canyon recreation.

Photographer Brent Houskeeper captures an image of the two-room cabin that was built near the spring. The little house shown on page 44 was on the right side of this cabin with a porch on the front.

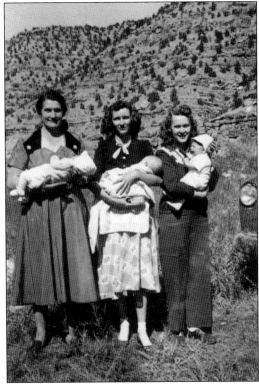

This image shows three Nine Mile Canyon mothers in September 1952 on the day their sons were blessed with names. Lucille Rich (left) holds her baby, Hugh, who is the last of her seven children; he is also the baby brother of Norma Rich Dalton (right). Norma's son, Wayne, and his uncle, Hugh, were the best of friends growing up. Arvie Lewis Rich holds her baby, Ray, whose father, Art Rich, is a brother to Hugh's dad. The blessings were held in the community building left by the CCC.

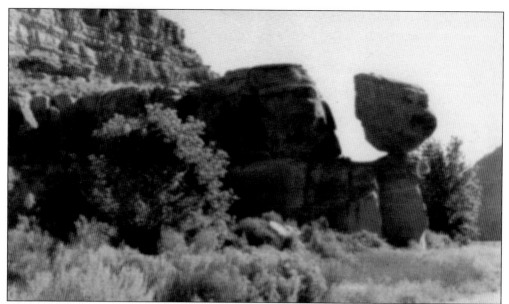

The Balanced Rock is an icon of Nine Mile Canyon, perhaps the most photographed natural wonder in the canyon. When the military came in 1886 to improve the pioneer road, it came upon a difficult double crossing of the creek at this site. The creek wound back and forth across the canyon, splitting the land up into pieces. Since the creek bumped into the ledge that held the Balanced Rock, then went south again, travelers had to cross it twice.

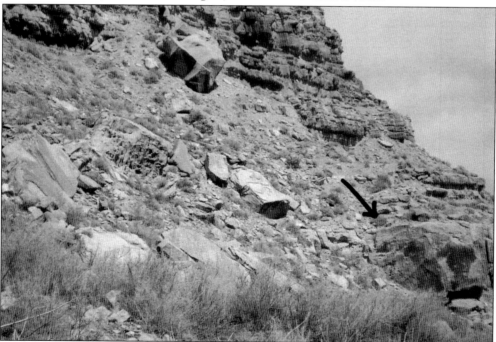

On the west side of the rock, the road builders cut a grade that went above the Balanced Rock then gradually went down to the level of the road on the other side, just above the old Hanks place. This old road grade is barely visible today, but can be discerned (see arrow). On the east side of the rock, builders filled in a narrow gully with rocks.

If the rock fill and road were built by the military around 1889, the road would be nearly 125 years old.

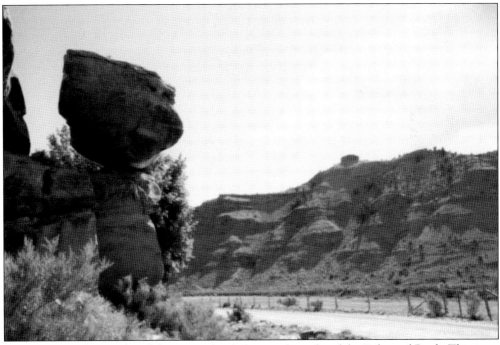

Notice the small, round, rock bump on the skyline to the right of the Balanced Rock. This is an Indian dwelling called Sky House by the professional archaeologist John Gillin, who excavated it in 1938.

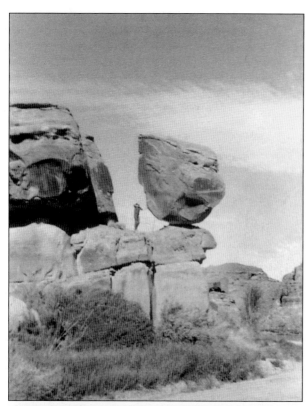

Once, there was a large broken rock behind the Balanced Rock that seemed to be supporting it. While the smaller rock did not touch it, some may have thought it did. A resident of the canyon, Harold Wimmer, used a pry bar and pushed that large stone away in the 1960s. Now visitors can see that the rock is truly balanced.

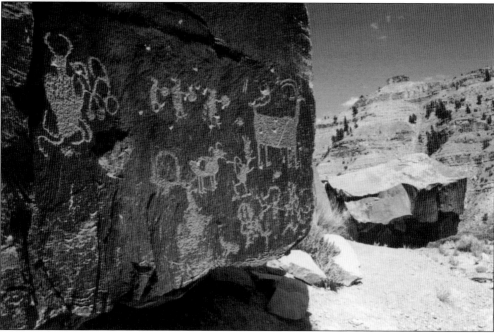

Prehistoric people often worshipped at a strange and different natural phenomenon. Evidence of this may be seen in the marvelous petroglyph panels in the area of Balanced Rock. (Courtesy Brent Houskeeper.)

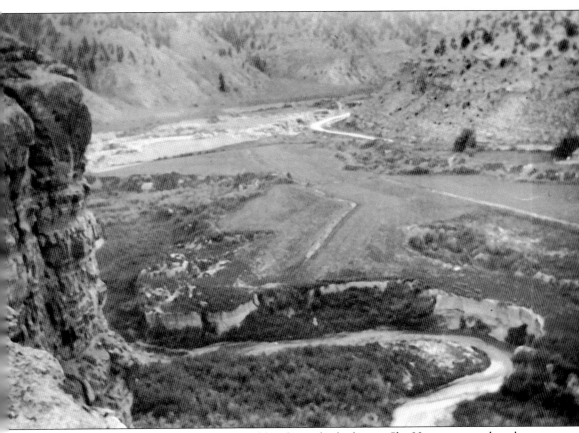

In 1954, this writer and her husband, Jerrold Dalton, climbed up to Sky House to see what they could see. They saw a lot of excavation there. The circle of ledge on top originally supported a rock-and-wood structure that had been burned. In the structure, a woman's remains were found with burn marks on her, according to the archaeology reports of John Gillin in 1938. Looking down, notice bushy creek channels that are filling up to someday become productive fields. The Balanced Rock is out of view around the corner where the road is bright on the top right of the image. Several times during the remainder of this book, the serpentine path of the Nine Mile Creek and the art of its particular life will be examined and marvelled at. As it turns the creek can twist marvelous fields into a willow-chocked wilderness. When the creek makes a turn, it erodes away the banks of existing fields, especially during flash floods. If the spot is critical to save the road, a house, or fields, the rancher rip-raps. This is done by securing a buffer against the raging water. The buffer might be an old car body, large boulders, or heavy tree stumps. These have to be secured by a "dead man," which is an equally heavy object wrapped with a cable and buried or otherwise secured, and the cable extended to the buffer. When the heavy rushing water hits the rip-rap, its power is defused and it can't reach the exposed bank to tear it away. In the middle of the above image, notice a white line in the shape of a 7; this may be an alternate ditch line. The fields are not always level in one direction. The rancher or farmer may cut a ditch along the higher planes of his field and send rows of water in a different direction to cover the entire field with water.

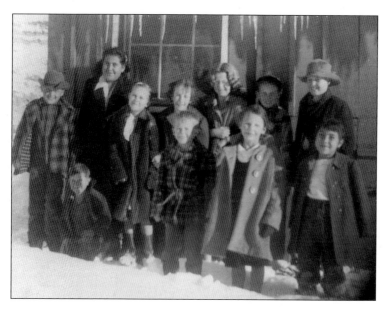

The last schools run in Nine Mile Canyon were taught by Lucille Wimmer in one of the green CCC buildings left in the canyon for that purpose. Pictured from left to right are (first row) Alva Clark, Kirt Rich, Elaine Wimmer, and Cecelia Gonzalas; (second row) Bus Rich, Della Gonzalas, Bobbi Clark, Arlene Wimmer, Betti Clark, J.D. Wimmer, and Don Rich.

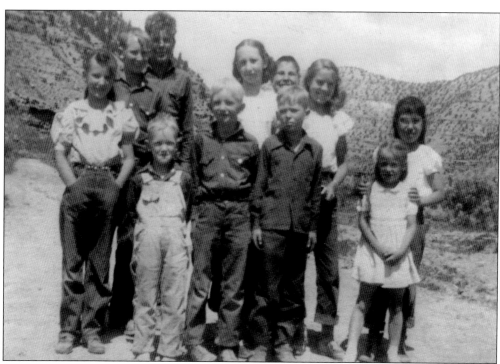

Pictured here from left to right are (first row) Elaine Wimmer, Billy Wimmer, Lee Wimmer, Kirt Rich, and Evelyn Rich; (second row) J.D. Wimmer, Melvin Keele, Arlene Wimmer, Raymond Gonzalas, Helen Robbins, and Cecelia Gonzalas.

This home was built by Minerva Stewart Hanks. Minerva and her first husband, Hank Stewart, had three children, Eva, Rex, and Vance. They divorced, and she was granted the homestead ranch of Hank Stewart at this site. Hank later married Elsie, and their child was named Arden Stewart. Hank operated a ferry at Sand Wash, which is a sister to Nine Mile Creek up the Green River a short way. Rex Stewart had an accident with a rifle when it discharged while he crossed a fence and he was killed. Minerva built this house with the insurance money. Kent Wimmer relates that while he commented on her nice home, she said with tears in her eyes, "She would give it all to have her son back." This home had the most conveniences of any in the canyon at the time. It had a nice bath tub. While it drained out into the garden and water had to be heated on a wood-burning stove and carried to it, it was a luxury. Everyone else still used a number three metal tub. It's a compact ranch with a water cistern for house use and pump at the kitchen sink. There were nice corrals, sheds, a shop, and a garage for Minerva's car and of course an outside privy.

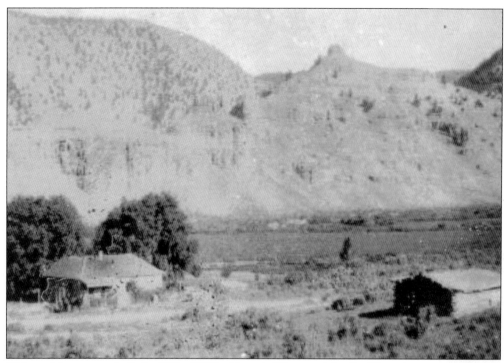

This rock house was built in 1884–1885 by Dennis Winn and family. He truly was a Nine Mile pioneer. The family also built a rock house in Argyle. His son, John, and John's wife, Fanny, had two children here after most of the family moved to the Uintah Basin. No one claims the rockwork down in the lower canyon, but this writer believes Frank Alger received help from his neighbor in building his rock cellar under his home. He could have built many other rock dwellings as well. This area has one of the largest landmasses in the canyon; however, getting water from the Argyle Creek required extensive ditching from a difficult dam site. Making a living in Nine Mile Canyon was, and still is, a push-and-pull effort, making men cuss. The cabin on the right side of the picture belonged to Montana Bob. Little information is known about the construction or the man himself. Kent Wimmer, who explored his new home when the Wimmers purchased the property in 1939, relates the initial "M" appeared on many locations—in metal or paint over doors, sheds, and corrals.

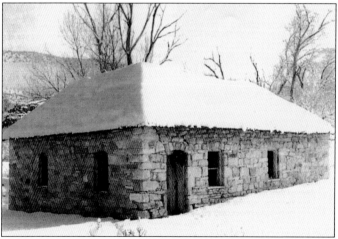

The Dennis Winn home has been called by the name of the person residing there at the time, namely, the Winn Rock House, the Harmon Rock House, the Mead Rock House, and finally from 1939, the Wimmer Rock House. This beautiful image was taken by Elaine Wimmer Goodrich on Christmas 2007. She lived in this house for her first growing-up years and attended school in the canyon.

A short side canyon enters Nine Mile from the north. While it has no serviceable trail to the higher country, it metes out much property damage with occasional flash floods. Named Wimmers Canyon, this canyon must have been related to the archaeological site at Sky House and probably had pit-house living areas along the creek. The Wimmer family explorations reported finding a set of teepee poles, stone implements, and other prehistoric materials in this draw. A draw is a very short version of a canyon.

This image of Trail Canyon was taken from Sky House. The view includes the lower fields of the Wimmer ranchers who owned this property for over 40 years. Trail Canyon comes into Nine Mile Canyon on the north side (left). It has a natural grade clear up to Lower Bench Road. The road went up this canyon in pioneer times. It is a mystery to some that Nine Mile Road would be changed to go out Gate Canyon, a twisting, treacherous canyon that lent itself to dangerous flash flooding.

In this image, the white line circling the middle of the image that crosses the mouth of Trail Canyon on the left side is the road. It follows around a point on the left of the image called the Big Bend. Those low ledges around the Big Bend are home to numerous petroglyphs. The dark line that cuts through between the fields enters the mouth of Harmon Canyon, which comes in from the south and has a name sign on its entrance.

Across from Trail Canyon, Harmon opens up on the south side. It is a steep climb for vehicles. The greatest trial for those maintaining this road is that the ledges come very close together near the mouth and the traveler has to pass through the drainage of the canyon. Any excess water, and especially flash floods, destroys the road.

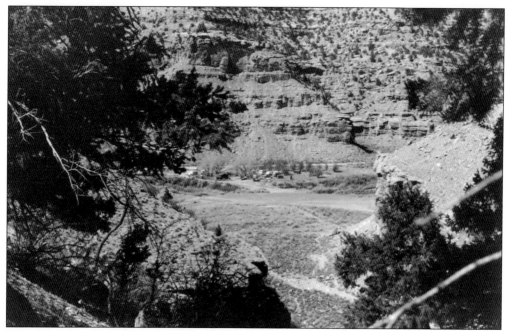

Whether hiking down Frank's trail or driving into his front yard, a visitor is always welcome. When Frank Alger claimed this piece of land in the late 1880s, he wanted to develop it, raise cattle, farm crops, and have an orchard. He planted an orchard of apples, plums, and pears; 100 years later, some are still producing.

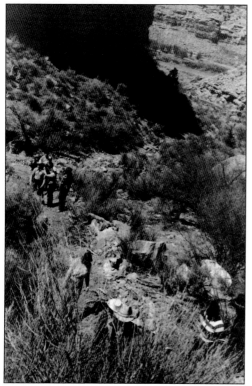

The next ranch after the Wimmers' on the Nine Mile Road is Frank Alger's ranch and storehouse. He blasted this trail out of ledges and used it to take his stock up the mountain to the summer range. Those people hiking down the trail, about 25 of them, are the descendants of his sister, Clarissa Alger Houskeeper, and her husband, Theodore Houskeeper. She was killed in a buggy accident in 1925. The father was in shock for years and took care of the family's sheep while Frank Alger provided a home for the family and jobs when they needed work.

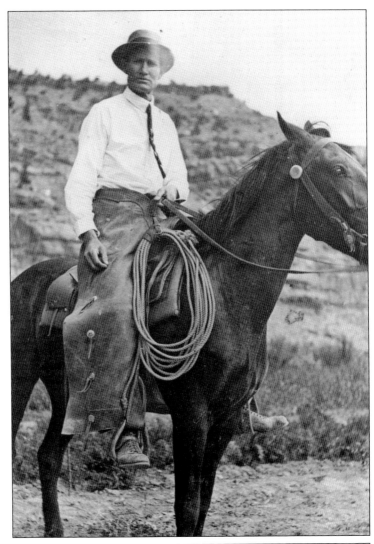

Frank Alger, a tall man, is seen at right on a horse named Streak. One of four brothers, Frank Alger and his brothers were all very tall—over six feet—hardy, working men. His older sister, Luna Alger, married Charles Smith in St. George, then moved to homestead in Nine Mile. Lon was a gambler, bootlegger, and Frank's irrigator between his follies. Gett, a steady worker, married a mail-order bride with two children. All three men were taught to handle tools and were builders. A younger brother, Joel, had health problems and worked lighter jobs.

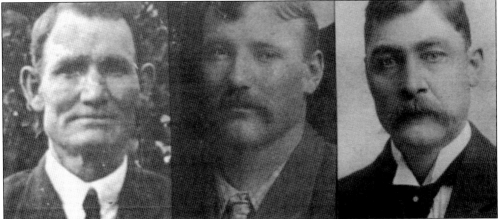

From left to right are Frank Alger, Gerritt "Gett" Alger, and Lon Alger.

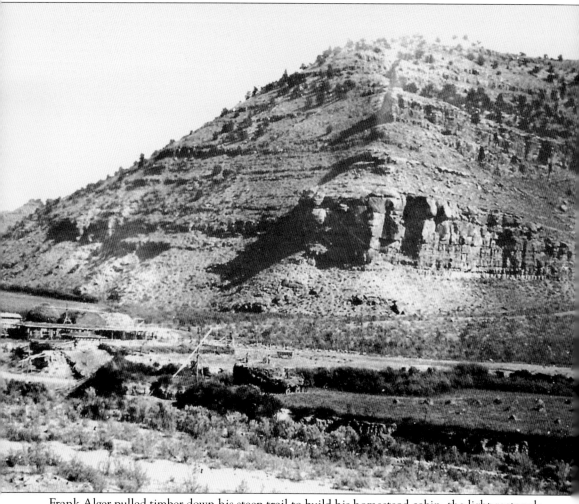

Frank Alger pulled timber down his steep trail to build his homestead cabin, the light rectangle on the extreme left of this image. Next he built the corrals with the stack yard behind them. Frank changed the course of the creek at his dam site. The dark line coming down through the middle of this image is the old creek bed. While it was gradually filling in the years to come he utilized the area to build a huge root cellar. He stored cabbages, carrots in bins of sand, all kinds of winter squash, and potatoes. He also had a potato pit close to the house for convenience. A person entered it by a ladder. On the other side of the old streambed, he built pig pens and raised many, many hogs to butcher. Close to the bottom of the image are men harvesting hay using a derrick and Jackson fork to lift the hay from the wagon onto the stack. Shocks of hay wait in the field for the hay pitchers to load it on the wagon.

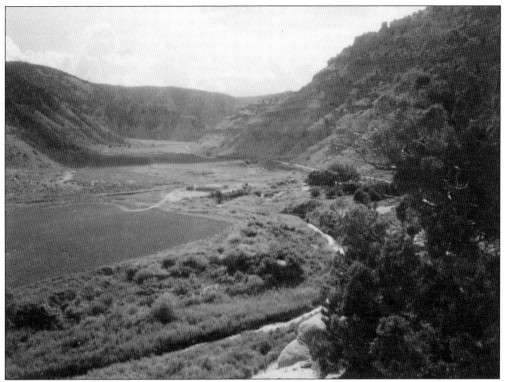

This image shows the land from the middle field west. Harmon and Trail Canyons are at the top of the image. The stack yards and orchard are in the middle of the image.

This image is the last one of the old lumberhouse. It had been changed many times before the current owner bulldozed the house into the rock cellar and burned it all. At that time, the house was 100 years old.

This image shows nearly all of Frank's storehouse. On the right side are the big double doors that allowed him to drive his team and wagon inside and out of the weather. There were double doors on the other side where he could take his team out until it was time to pull the wagon through. The image shows three-year-old Lucille Houskeeper. On the north side of the building was a partitioned-off meat room. It always had barrels of pork curing. Sides of pork and bacon slabs hung on large hooks all around the room. There were shelves of household needs along the back wall. On the other side of the meat room was a pool table with a heater nearby. Hardware and farm implements were along the west wall. He had a large, ornate, gold-colored cash register and a drawer with charge books below the register. He hauled barrels of kerosene for use of canyon people. During the long Depression, no Nine Mile family went without light, food, lots of apples, meat he raised, and commodities he bought. When Frank passed away at the age of 71 in 1938, he left his ranch to his two nieces who lived with him after the passing of their mother. The girls and their husbands were Lucille and Thorald Rich and Janie and Al Hancock. When an accounting was taken, the ranch was deep in debt. The couples looked over the charge book and knew that they couldn't collect the debt because of the times. They burned the collection books, closed the store, and started working on the debt. Al died the next year with stomach cancer. The remaining three worked, paid off the debt, and sold out in 1956.

Seen here is the old orchard as it appears today. This is a lengthy recitation of one rancher's life in Nine Mile Canyon. It is possible that the ease with which Frank Alger was able to acquire water helped greatly in his ranching success. However, he too spent many hours and days digging out mud-clogged ditches and repairing dams.

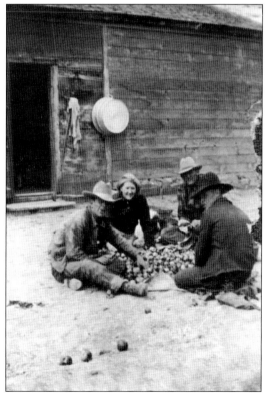

Three huge bins of apples, or what was left of them when spring came, were carried up those stone cellar steps to the yard and carefully sorted. Those that were not in good shape were hauled to the pigs. Those that would last longer were stored in burlap bags and returned to the rock cellar, where it was cold and dark. No one ever paid for an apple or any garden stuff; all were welcome to what they needed. From left to right are Al and Janie Hancock, Ted Houskeeper, and Thorald Rich.

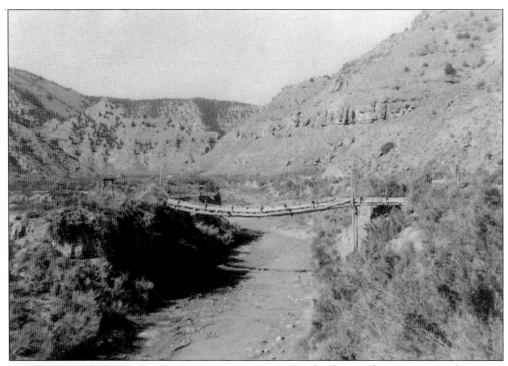

Frank's dam took water out on the south side of the canyon. When he wanted to plant his orchard and build his home and storehouse on the north side, he built a flume of lumber to transport the water to the north side. He also cleared a small field below the orchard where he raised alfalfa hay.

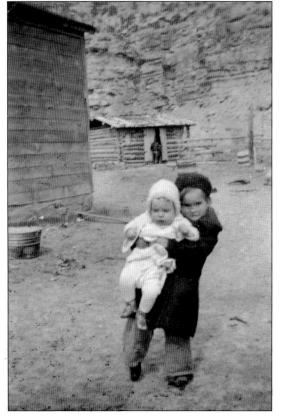

Frank's blacksmith shop was situated above the ditch to the orchard and above the lane down into his property. The children in this image are Frank's great-nieces; Norma Rich is holding Clara Hancock.

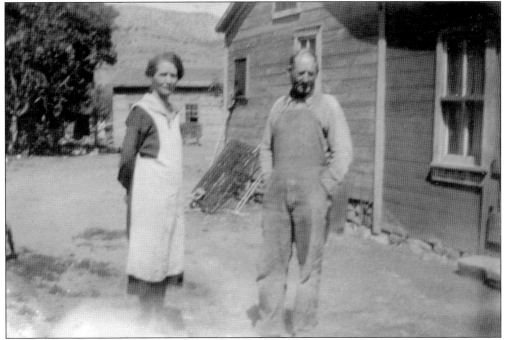

This image shows the rock cellar Frank built under the first room of his house. The cellar had shelves for bottled food and three large bins for apples he stored through the winter. The couple pictured is Theodore Houskeeper and his sister Emma Smith.

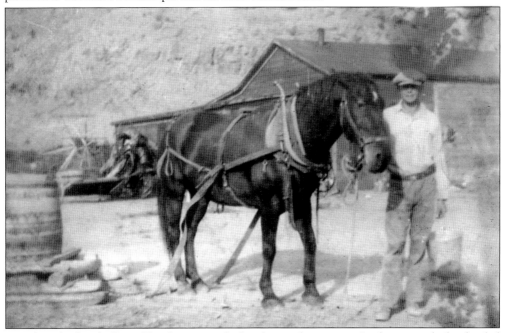

Lee Shaw, husband of Fern Houskeeper, worked at the ranch part time. In this image, he has hauled a barrel of water up from the creek. All water comes from the creek, whether it be for drinking, washing, bathing, or for the animals. In the winter, this same water sled, with two barrels, hauled water to the pigs. In the summer, irrigation water drained from the fields into their pens.

Thorald and Lucille Rich are seen here with three of their seven children (from left to right are Earl, Norma, and Don). At 25, Thorald became part owner of the Frank Alger Ranch. His wife, Lucille, Frank's niece, was a great help since she had lived on that ranch many years. Thorald's sons became his ranch hands at a very young age.

Visitors at the Algers' ranch included, from left to right, Helen (holding baby) and Shorty Smith, Mental Taylor, Lucille Houskeeper, Shorty's son, Frank Alger (in hat), and Janie Houskeeper.

Al Hancock and Janie, part owners of the Frank Alger Ranch with Thorald and Lucille Rich, are seen here. After Al's death, Janie cared for their two children and helped on the ranch, milking, gardening, preserving food, and whatever was needed. One year, she leased the old Johnstun place and raised turkeys. After the Nine Mile School closed because of World War II, Janie moved to Wellington and sent the children to school. While there, she worked school lunch. In late 1948, she remarried and moved out of the state.

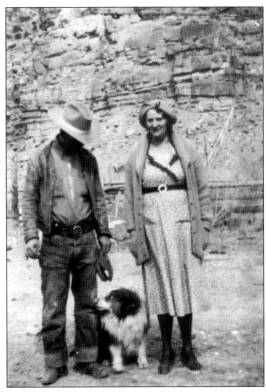

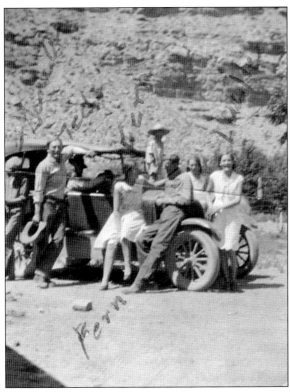

Friends come calling in this image. Here, Gene Alger, Ted Houskeeper, Fern Shaw, Lee Shaw, Lucille Houskeeper, and friends are seen.

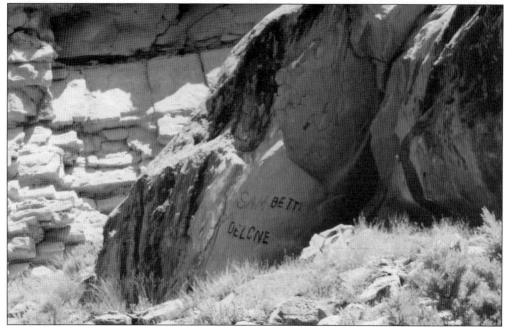

Leaving the Alger place and going down the canyon, there is a little field with a very high ledge by the road and a large boulder that has three names on it that were put there in 1950. The first name listed is Sam, followed by Delone Rich and Betti Clark, who added their names so that Sam's would not be lonely.

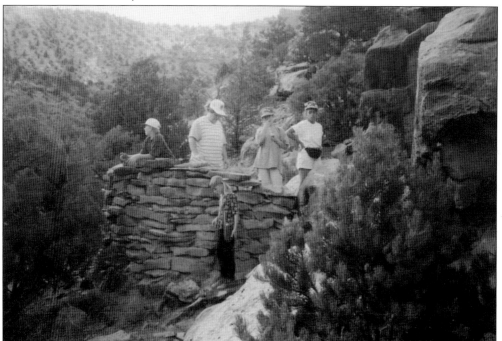

On top of that ledge is a very lovely tower. The locals called it a lookout because inside the rock walls there are two square holes that a person can see up and down the canyon a long ways through. These may have been for safety measures.

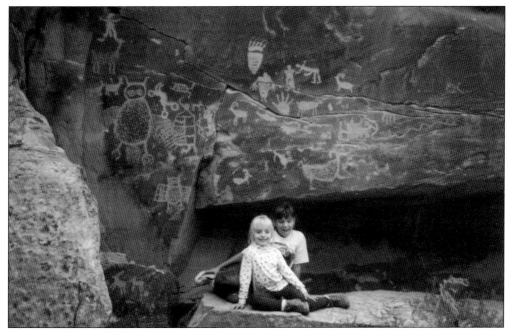

Alger Canyon opens up next. The flood plain is high, and a rise travels over it. On the east side of this canyon not far from the road are outcroppings close to the ground that have many petroglyphs. The largest and most impressive one is called the *Owl Panel*. Two little girls, Brittany Christensen and Jordan Dalton, pose beneath the *Owl Panel*.

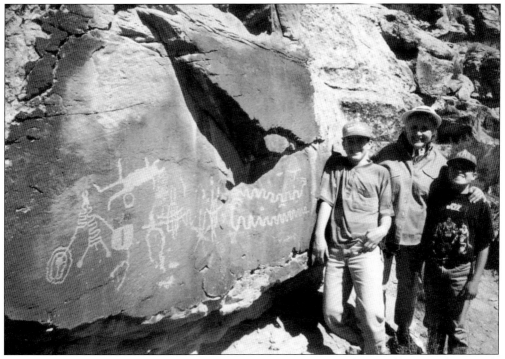

This petroglyph is near *Owl Panel* and is being viewed by Norma Dalton and her grandsons, Kyle and Bo Dalton.

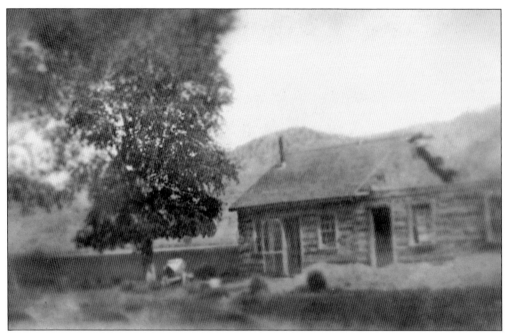

Early homesteaders named Egan opened this ranch about 1880. Their little cabin grew into a very large log home before it burned. Several owners cared for the property; one outstanding caretaker was Mental Taylor. Current rancher George Fasselin keeps the farmland in excellent condition. Water must reach these arid lands to keep them green.

John Egan was responsible for this building of rock and logs. The west part was a blacksmith shop, and the east part was a saloon.

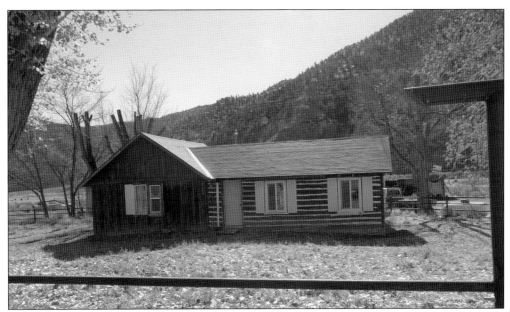

The first part of this house, the gable end, was built by Cecil Rouch, who owned the property at that time. Thorald Rich helped him build it. When Rouch sold to Rich in 1946, Rich enlarged the house by adding logs from the old Alger storehouse. He leased the old Alger home to other families who helped with the farming. Thorald Rich sold out in 1956.

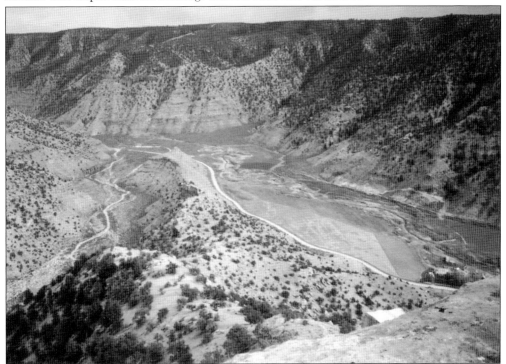

This image shows the ridge down through the center of Currant Canyon opening on the north (left side). The road on the right side borders the Egan property. Today, an energy company has a pipe yard at the bottom of the Egan Ranch at the cattle guard in the mouth of Currant.

Currant Canyon has many prehistoric writings and images. One panel looks like a map. Following it, one climbs high on a ridge. A tar-like substances can be found seeping from the ledge. This product may have been used by prehistoric people to seal their baskets, making them watertight and able to carry water.

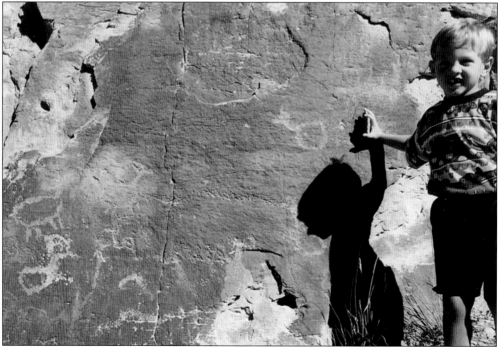

Boedy Dalton is seen here at petroglyphs along the ledges below Currant Canyon on the left side.

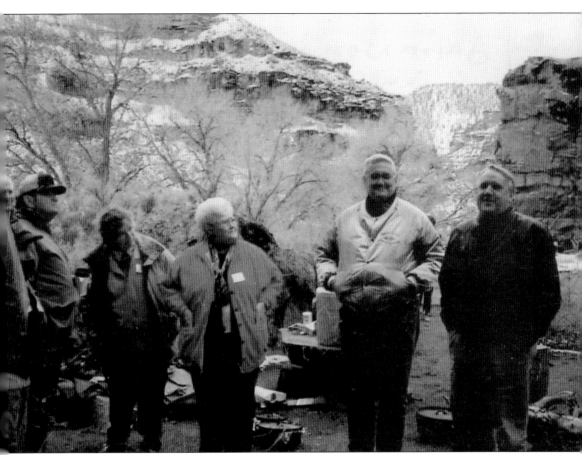

The Castle Valley Chapter of the Utah Statewide Archaeological Society was formed in 1985. Their chapter participated in guest lectures, tours, field trips, and classes in archaeological certification that would enable them to do surveys and participate in excavations. Knowing about this canyon and wanting to take part in preserving its archaeological treasures, they became involved with Carbon County commissioner Emma Kuykendall, who appointed Castle Valley Archaeological Society (CVAS) members to serve on a Historical Preservation Committee. This committee was able to obtain funding to do survey work in Nine Mile Canyon. They were able to hire two professional archaeologists, Drs. Ray and Deanne Matheny, to guide over 50 volunteers in recording over 100 sites in the summer of 1989. In 2012 and 2013, with funding long gone, there were 175 sites recorded and over 8,000 volunteer hours logged. CVAS members received much recognition for their survey work and later for labor in preparing the Cottonwood Glen site. The Bureau of Land Management state director, William Lamb, thanked them with a plaque and letter for their work along with other agencies for this much-appreciated place for canyon visitors to enjoy refreshment and comfort. Who cares about Nine Mile Canyon? CVAS cares! (Image and text by Margene Hackney.)

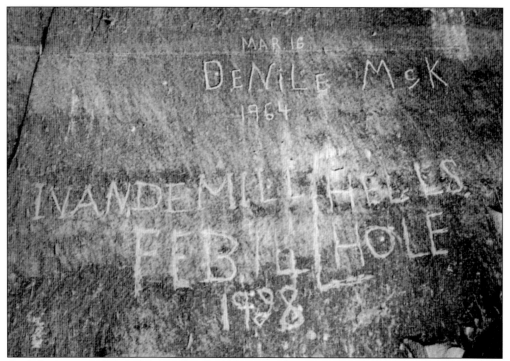

On February 14, 1928, Ivan DeMill, a freighter, scratched on a ledge opposite Warrior Ridge his sentiments on freighting through Nine Mile Canyon, which is usually bitter cold in the winter, calling the area "Hells Hole."

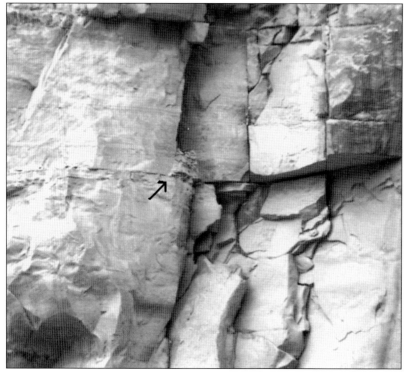

A short way down the canyon from the above inscription is a prehistoric granary. It is in a crack with black writings around it. Small timbers can be seen supporting the adobe and roof.

Seen here is Warrior Ridge, which is on the south side of Nine Mile Canyon. There is a mountain behind it; in between the ridge and mountain is a small canyon called South Pete's. To see the petroglyphs, one must climb to the top of the ridge; immediately on crossing over, along the light-colored ledges, there are many petroglyphs, most in a combatant posture.

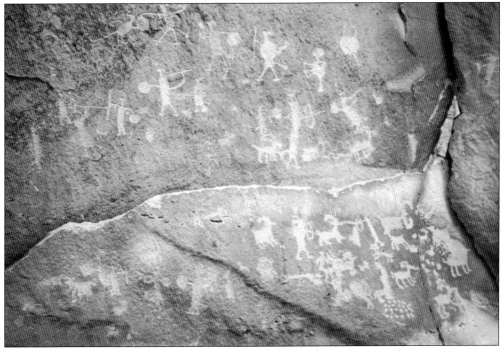

There are many images showing figures with shields, clubs, drawn bows, and arrows, seeming to be in combatant positions, thus the name Warrior Ridge.

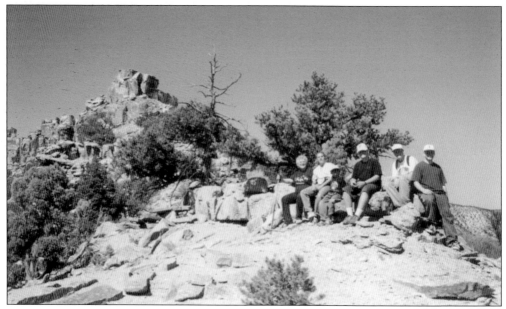

Notice on the image of Warrior Ridge on the previous page the round knob in the center; it contains a small dwelling. There is another geological feature like it on which is another site above the people in this image. The hikers have crossed over the ridge and are ready to descend to see the glyphs.

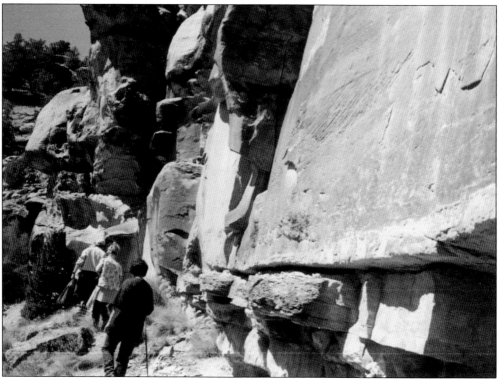

Hikers are seen here walking next to the large panels. Most surfaces in this area contain etchings.

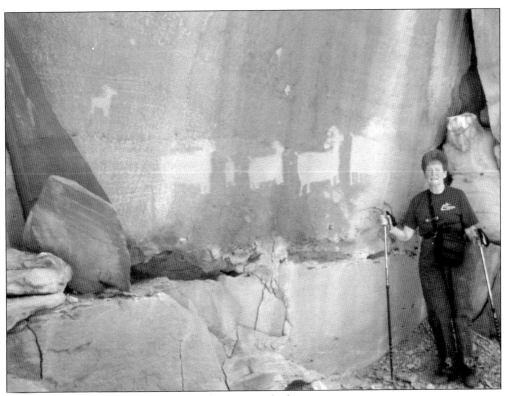

Edythe Marett pauses to examine very large petroglyphs.

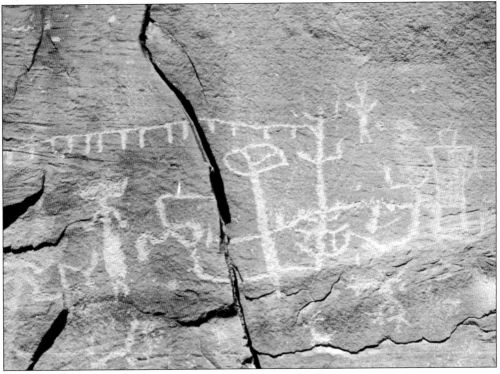

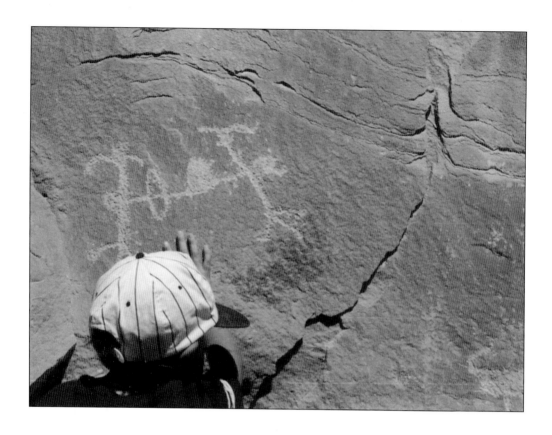

It seems these quarreling figures have caused the animals to flee. Here, the elk retreats one way while the sheep goes the other.

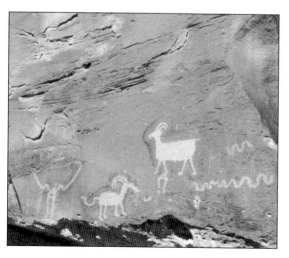

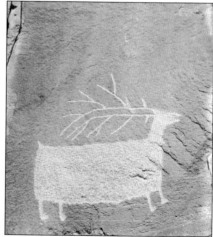

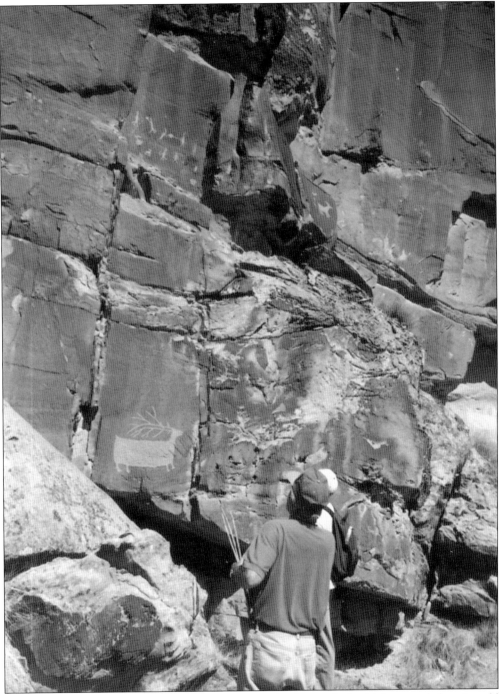

It's very common in Nine Mile Canyon to see panels of petroglyphs high up on ledges. Jerrold Dalton is seen here in front of one such panel.

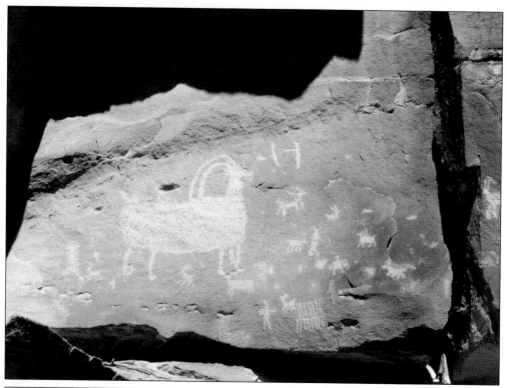

The exact species of the animal seen here is unknown, it seems to be a baby tender or school teacher.

Behind this hiker, one can see the point, or knob, visible from the road with the canyon beyond. The Nine Mile Road follows the mountains on the left side, and the creek follows the mountains on the right.

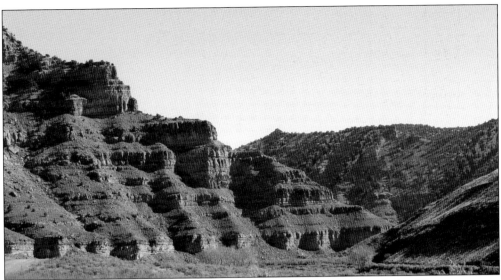

This image is looking down the canyon toward Nutters Ranch from Warrior Ridge. The next canyon coming from the north has a good riding trail to the winter range. It is called Pete's Canyon. The flood wash out of this canyon hits the road, which is going slightly downhill, and when the flood follows the road it has done considerable damage, especially when filling structures with mud.

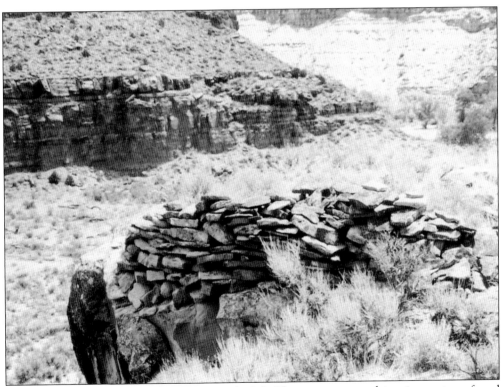

Pete's Canyon enters Nine Mile Canyon on the left. There are many prehistoric structures found along this canyon. These dry-wall buildings covered this point and are visible when coming down the canyon.

Directly across the canyon from Pete's is a dry-wall tower. Some observers believe that it might have been used in detecting unwelcome visitors before they reached the homes of residents.

Ahead are the Nutter Ranch buildings and some military structures left from occupation along the Nine Mile Road from 1886 to about 1892. The resident buildings have burned twice. These newer ranch structures were built in the 1940s.

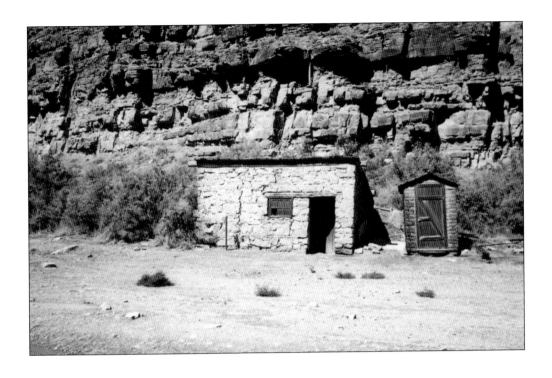

These images show the military's telegraph office along with adjacent military buildings.

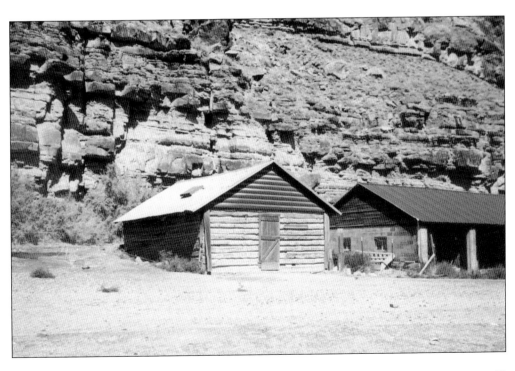

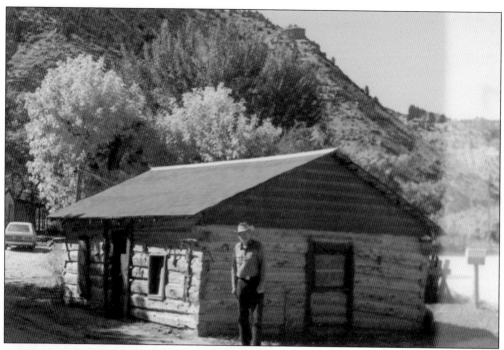

In this 1975 image, Ted Houskeeper stands in front of the saloon built in late 1800s. Since this image, several flash floods have brought tons of mud down the road and filled the building and surrounding area until the cabin was covered with two feet of mud and dried dirt.

The Nutters were famous for their peacocks. In 2011, the present owners contacted Ben Mead, who restores cabins at the Nine Mile Ranch, and told him that the saloon was soon to be bulldozed and asked him if he wanted to restore it. The Meads are trying to preserve the history and heritage of the canyon and hope to offer a museum in the future for Nine Mile Canyon visitors. They have received a grant from Bill Barrett's Archeological Conservation Trust (ACT), which helped to get the restoration of the old saloon underway.

The Nine Mile Road passes a green hay field and turns up Gate Canyon to leave Nine Mile Creek with its continuing life-supporting water forever. Present-day signs give the mileage of cities and towns in the distance.

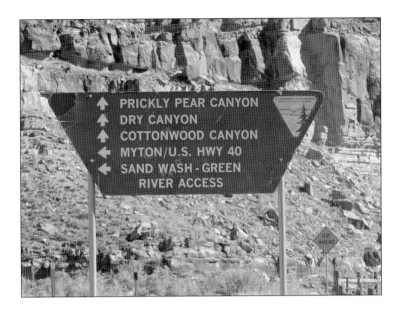

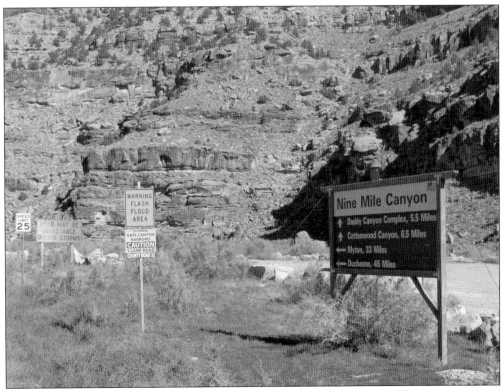

This sign gives mileage to two stunning archaeological sites downstream. The story continues to the mouth of Nine Mile Creek where it enters into the Green River. Before continuing that journey, the road up Gate Canyon will introduce readers to the Wrinkles. It's a short by-the-way bonus for visitors today or while on another trip to the canyon.

As the traveler turns up Gate, he may wonder, "Why the name Gate Canyon?" H. Bert Jenson explains in a brochure he wrote in 1984 titled "The Pioneer Saga of the Nine Mile Road." Not quite a mile from the mouth of Gate Canyon, there was a ledge spanning over the ravine. Bert writes: "It was destroyed about 1905. Iron-rimmed wheels on the wagons caused vibrations sending small rocks atop the arch over the edge where they sometimes fell onto the wagons passing underneath. . . . Some people became convinced that the arch was decaying . . . and someday someone would be crushed under the massive stone as the arch collapsed." Because of this fear, the owner of the Stage Coach line convinced others to hire a crew to blast it down. Many lamented the deed, feeling the action was premature. This prominent ledge bordering the wash looks much like an anchor of the real arch, which is a short way above this one and marked by a round metal sign No. 12 on the wash side of the road. This image was taken near a cattle guard built to keep stock from drifting up Gate Canyon. The barricade in the wash bottom was built for the same purpose.

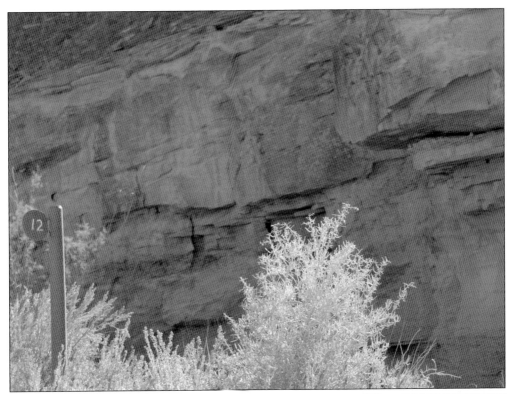

The No. 12 sign is shown here.

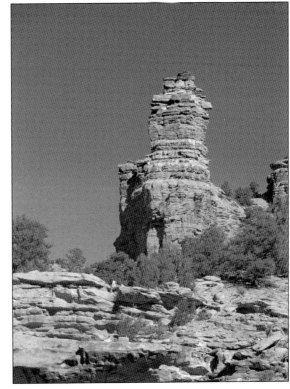

Twisting up Gate Canyon Drive, many beautiful ledges and formations similar to this one can be seen. Five miles from the turnoff at the mouth of Gate Canyon is Sand Wash Road, also referred to as the "bench" road to Sand Wash or Green River.

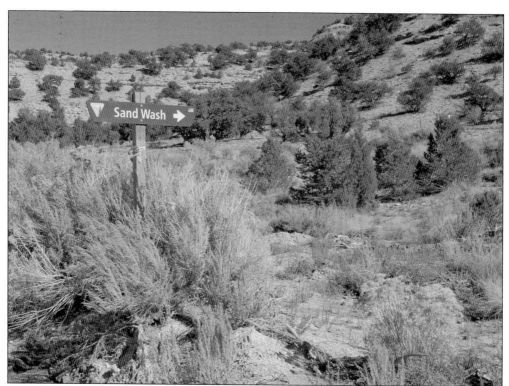

Five miles from where the traveler turns off the Nine Mile Canyon road and follows the Freighter Road up Gate Canyon, this Sand Wash sign announces the turn off to the east heading to the Wrinkles.

This image shows the road from Myton on the right side and the road to the Wrinkles on the left side. Looking down the road on the right, the point where it drops into Gate Canyon can be seen. Also in the distance, the snow patches are across Nine Mile Canyon in what is called the "high country." The summer range includes Big Mountain, South Ridge, Prickly Pear, and the top of Harmon's Canyon.

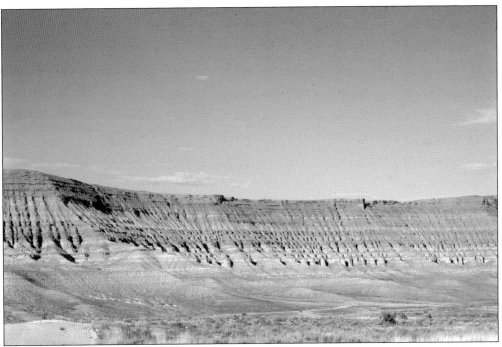

Going down Sand Wash Road, travelers pass through several miles of pinion pine and juniper trees, as well as an energy site filled with storage tanks; in the distance is Wrinkles Mountain.

This unusual erosion formation has changed little over time because of the lack of rain in the area.

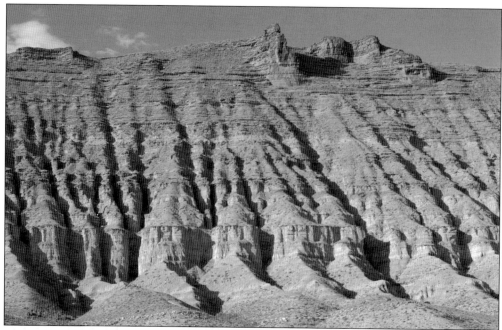

This is an interesting landform at the base of Anthro Mountain, which is the mountain that separates Nine Mile Canyon from the Uintah Basin. At the base of the Wrinkles, Sand Wash has a road down the flood wash to the Green River. A short trip brings the visitor to the ranger station on the river and some old cabins used into the 1940s. The newer shelters are screened cabins, mostly used by river runners or floaters.

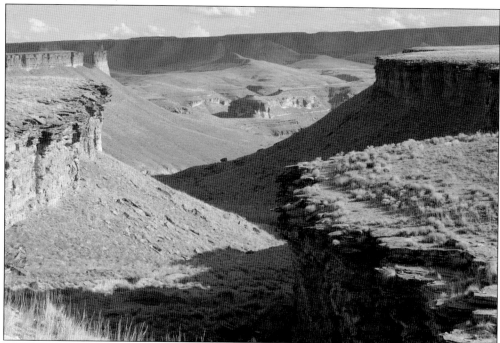

Shown here across from Anthro Mountain is Nine Mile Canyon in the distance. In the middle of this image, the ravines opening up drain into the canyon proper.

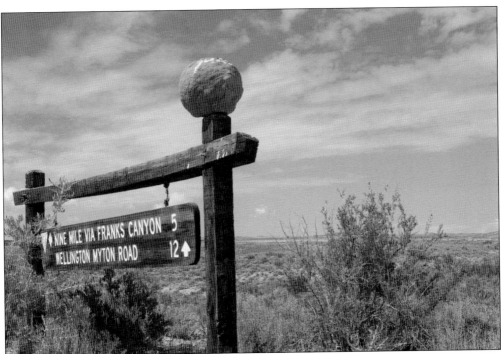

Twelve miles from the Gate Canyon turn off is Franks Canyon, where visitors can travel at a steady downward slope to the Nine Mile Road. Travelers need to be aware that each flash flood may change the course of the fine-chipped rock roadbed, and they may have to move a large rock occasionally. However, it's a fun five-mile ride.

The Sand Wash Road loops around the end of the Wrinkles and joins another road that comes from the north; both head down the wash, which is filled with marvelous ledge formations.

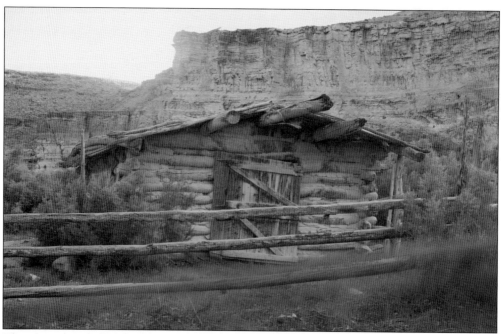

There are several old cabins; most are filled with flash flood mud from Sand Wash's wide mouth. Groups getting ready to float the river can often be seen. On some weekends, several parties may be leaving near the same time.

This group is leaving in July 2013 to do an archaeological survey in one of the canyons opening into the Green River. They plan on taking nearly a week to complete their project. Their organizer and leader is Jerry Spangler (pictured), a journalist and archaeologist. Leaving this by-the-way venture, travelers return to Nine Mile Canyon.

Three

STICK FIGURE LEDGE TO GREEN RIVER

Leaving Gate Canyon to continue down Nine Mile Canyon, the traveler crosses the wash. Immediately, one can see many small petroglyphs along the ledges. These are called the *Gate Canyon Wash People*. Just a short way past the bend is a small ravine opening up to the ledges higher up from the road. This is called Stick Figure Ledge by Nine Mile Canyon Coalition members who have done extensive surveys in the canyon. This would be a great place to spend several hours exploring.

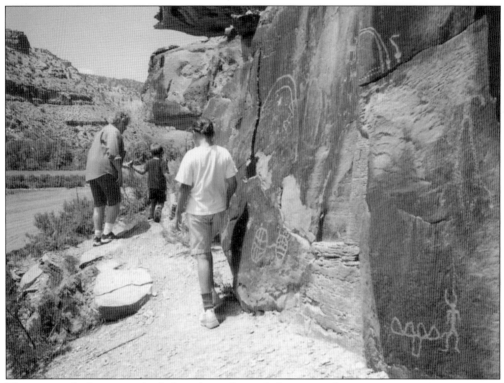

These petroglyphs are on the ledges above the stick-figure panel.

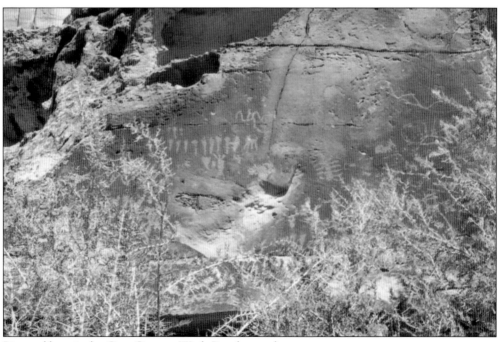

Pictured here is the Gate Canyon Wash People panel.

This image was taken in the late 1920s of the Nutters' stack yard. The hay and board fence are now gone. Looking up at the eroded ledge, created because of sizeable flash floods over time, one can see in this picture water pouring off the cliffs.

Pictured is a granary that has had the front caved off. Nearby are two canyons: Water Canyon on the left, coming from the north and across the creek, and Olsen Canyon on the right. Olsen has a stock trail going up on the summer range and was named to pay homage to the first settler on that side of the creek. When his homestead was sold and became part of the Nutter property, his family left the canyon.

The Water Canyon corral is still in use on the right side of the road. Looking to the left up the canyon, one sees the activity of energy production in the canyon as a gas pipeline comes down and crosses over to the south side to continue toward the Wasatch Front. The deep wash has no water except in a flash flood. However, in the head of the canyon, there are seeps that take care of stock grazing on the benches.

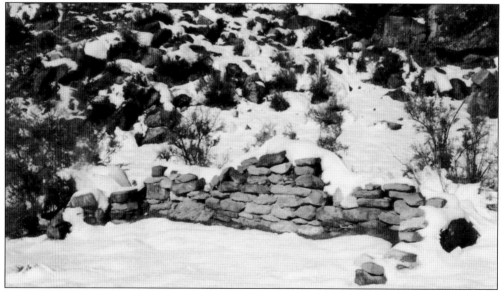

Blind Canyon really isn't—there's a horse trail up Blind, but it wasn't normally used. A family homesteaded here and built two rock houses. This image shows part of the largest. They had many additional storage structures, but the prehistoric people had rock structures here as well, making it difficult to distinguish who built what. A huge field extended to the creek that is now behind a road construction pile of rock.

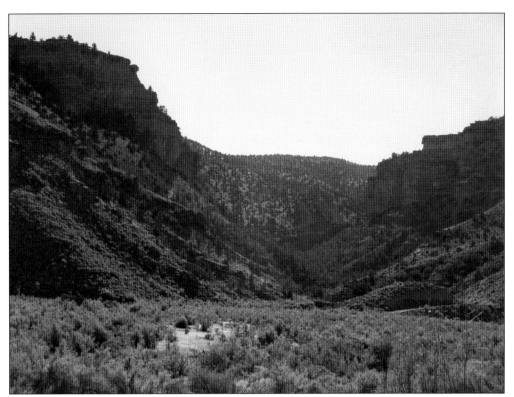

Immediately past Blind Canyon wash, on the right side, the Prickly Pear road leads out and crosses Nine Mile Creek. Here, a road cuts along the low, small hill and continues up Prickly Pear Canyon; it was the first road built up to the summer range on Big Mountain and South Range. The Cottonwood Canyon road reaches the lower summer range. Before this road was built, all supplies, rock salt, and branding equipment had to be taken up by packhorses.

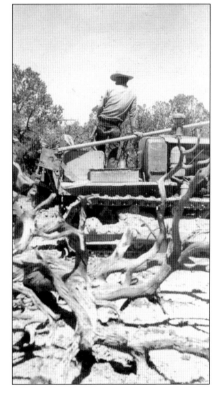

The Rich brothers Thorald and Dave built this road in 1946–1947. Dave started with a D4 Cat; when the road was nearly to the top, they obtained a D6 to finish the work. At right, Dave Rich is operating a Caterpillar.

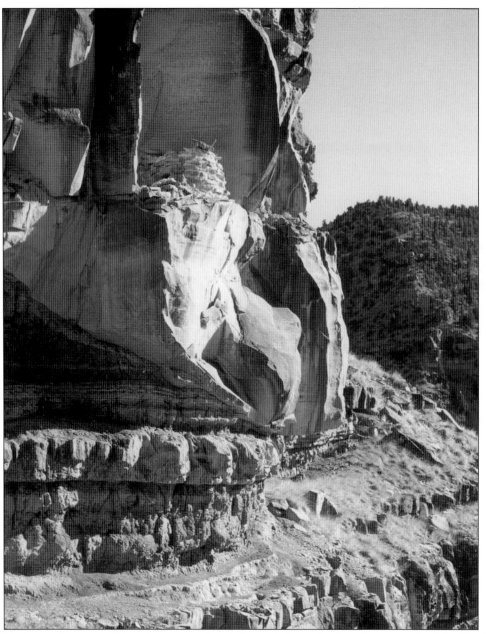

This image shows a prehistoric granary that is located above the board gate on the left side of the road. To separate the properties, ranchers fenced from one side of the canyon to the other and put a gate across the road. There were 13 gates between the Rich place and the lower ranch. These gates were usually made with strands of barbed wire separated by small posts or poles to hold the wires apart. There were usually at least three in-between posts that were heavy and hard to hold when dragging the gate to the side of the road. To open the gate, one lifted a heavy wire (or chain) up off the top and lifted the bottom of the gate out of another heavy wire loop attached to the main gatepost. At this site the gate was made of boards; one could pull the slide and it swung open easily for vehicles to drive through, and one could hitch a ride on it when it swung back.

Across from the board gate is Redman Village. There are multiple dwellings of several kinds. The tower shown here is on the left side of the draw. There are adobe walls and dwellings in the ledge on the right side and many petroglyphs and pictographs in the area. One has to cross the Nine Mile Creek to reach this place.

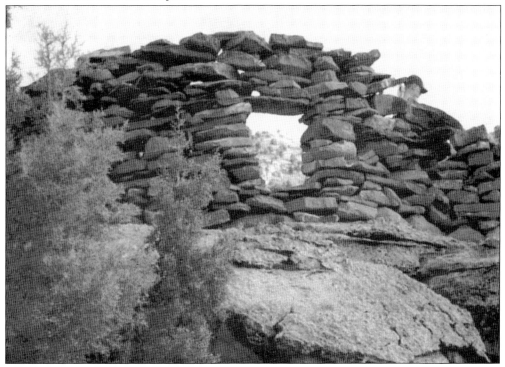

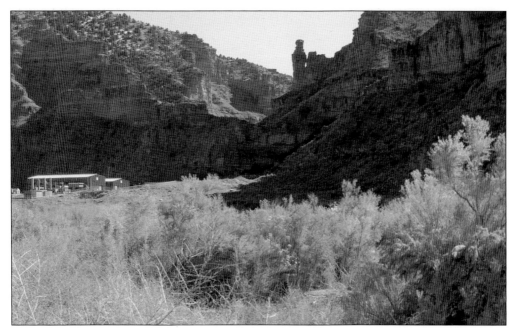

In the mouth of Dry Canyon, there are two prominent features: a gas-compression station and a rock formation in the ledge called the Mummy. Dry Canyon is home to a huge spring that merges down to join Nine Mile Creek year-round. The first homesteader here was Harrison Russell, known as "Daddy" Russell. The image below is the famed Rasmussen Cave. Across from Dry Canyon, Daddy Canyon boasts the longest line of petroglyphs in the area. The figures start in the ledges before the Rasmussen Cave and continue throughout the cave, on around the right side, and behind the corrals and the mouth of Daddy Canyon before they jump over and pick up on the east side of the mouth and on along the ledges to the road. They are on several layers.

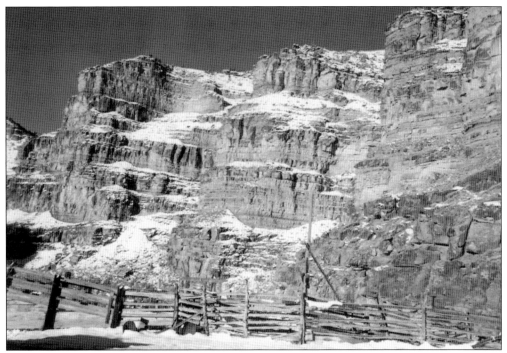

This corral is on the west side of Daddy Canyon, so named for Harrison "Daddy" Russell. The corrals and loading dock are very old but sustained by continuous use.

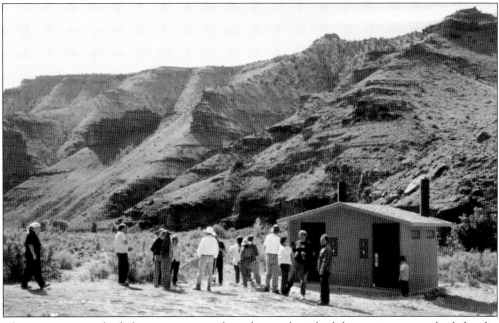

These restrooms, shaded picnic area, parking lot, and trail of the ancients were built by the Bureau of Land Management (BLM) with help and funding by other agencies that wanted to provide comfort for canyon visitors. The Nine Mile Canyon Coalition provided restroom service by cleaning them for years; members carried buckets, water, soap, mops, and toilet paper in their cars to take care of the restrooms. Some made special trips to the canyon just for that purpose.

The coalition has held an annual Fall Gathering, usually in the canyon, to share canyon developments, activities such as tours, and entertainment. At one such activity, the grand-daughters of Preston Nutter (Katherine Hodkins on the right and Virginia Anderson on the left) visited with the coalition members and discussed some of the history of their grandfather, the cattle baron of Nine Mile Canyon in the 1900s. Board member Edythe Marett interviews the two. Nine Mile Canyon Coalition continues to monitor developments in the canyon. One of the major accomplishments of the coalition has been the listing of Nine Mile Canyon in the National Register of Historic Places. It took years of dedication and work with the Bureau of Land Management and the Utah State Historic Preservation Office, but sites in the canyon are being added yearly as part of the programmatic agreement stipulation. (History compiled by Dr. Pam Miller.)

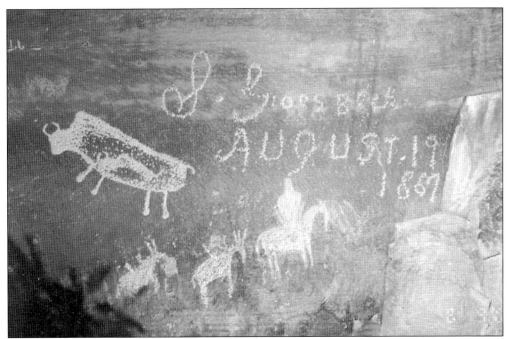

Shortly after visiting Daddy Canyon and continuing down the road, the travelers come to a fork in the road. Taking the right side, they head up the Cottonwood Canyon road. On the first big bend in the road, watch for the Big Buffalo Site, which showcases a large pictograph of a pregnant buffalo. Above the pregnant buffalo are beautiful pictographs made with many colors. There are quite a few pictographs in the canyon, though they are usually hard to find. This one is exposed to the elements, which is rare.

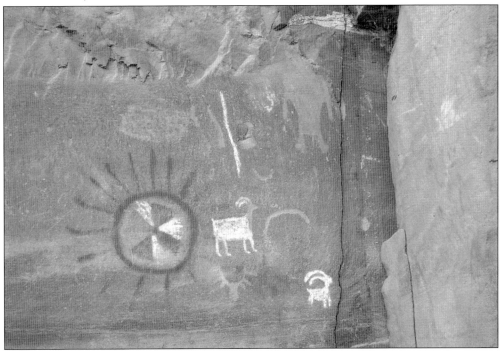

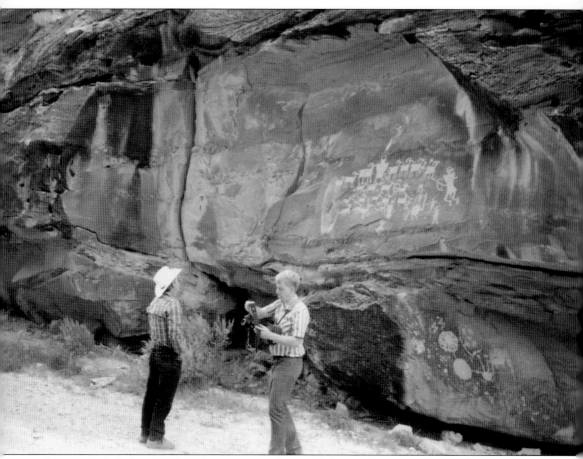

Lon Rich (right) and Kyle Dillon examine the world famous *Cottonwood* petroglyph in this c. 1993 image.

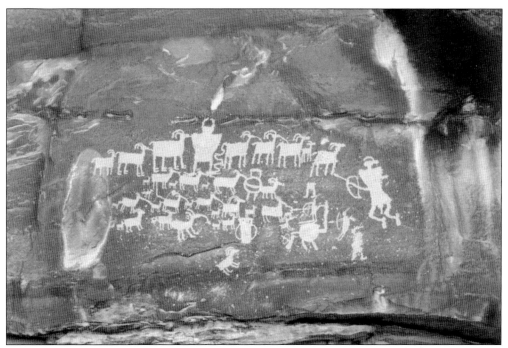

The locals referred to this petroglyph for years as *The Hunter's Panel*. Of late, professionals call it *The Great Hunt*.

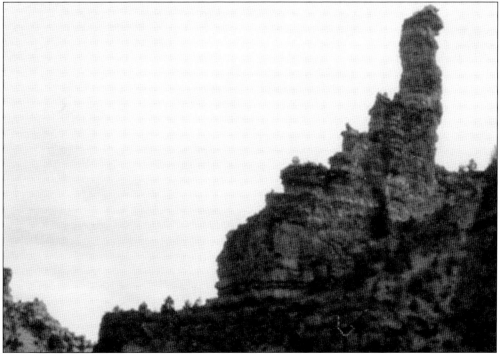

Cottonwood Canyon climbs out to the top of this range. To continue down Nine Mile, go back to the fork in the road and take the left side. The Cottonwood Dinosaur, seen in this image, is one-eighth of a mile beyond *The Hunter's Panel*.

This image shows the winter calf pasture. After traveling down the left fork in the road a short ways through a fence and a field, look up the mountain on the left side. Notice how the ledges seem to be in steps or layers and there is grass in between these layers; this is feed for livestock. It was out of reach until Thorald Rich blasted a trail up through the ledge. Arrows show the path the cattle took to reach the winter range. This trail could be closed with a couple of bars, and the cattle could feed as long as there was snow for water.

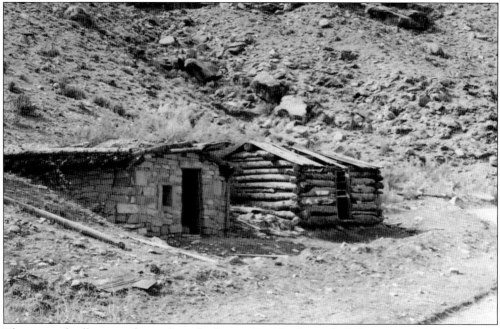

These two dwellings are located on the Lower Ranch; the rock shelter was the homesteader's cabin, and the log dwelling was a cabin that outlaws built up Chimney Draw. It was pulled down log by log and reassembled here. There were a total of five units in this place: a rock cellar, a bunkhouse, a cabin, and these two. An arsonist destroyed the other buildings.

Devils Butte, nearest on the west (left side) of the canyon, has multiple layers of dwellings with a cap-rock lookout. The entrance is on the back, and one has to enter through a small square door, making it easy to defend. Up high on the skyline is another butte, about center in the image; it too is a dwelling with pit houses in back.

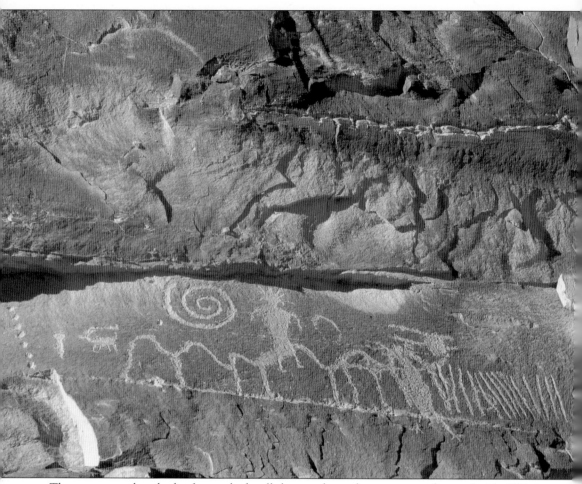

There are many hundreds of petroglyphs all the way down the canyon on the north side. This is only one of many at the bottom of the Lower Ranch.

Pinnacle Canyon, located on private ground, seems unpretentious at the mouth of the canyon. Here, the marvelous pinnacle is seen from various perspectives. It is estimated to be about 300 feet high.

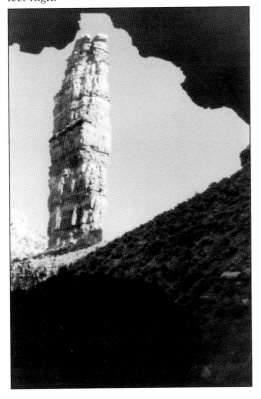

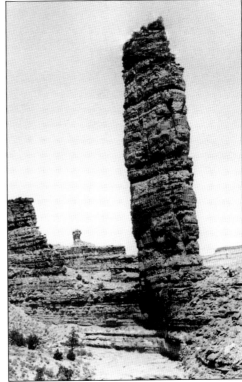

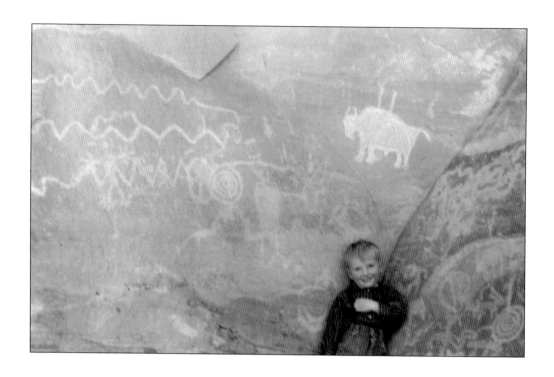

These images were taken by Thorald and Lucille Rich in 1954 with their seventh and last child, Hugh Rich, in Pinnacle Canyon.

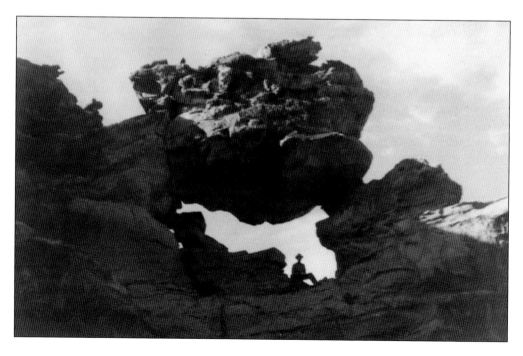

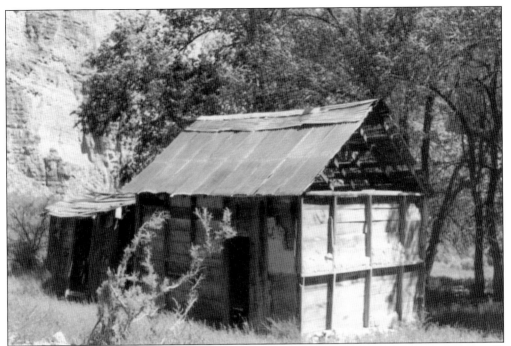

This photograph is of the Clark Elmer Ranch. The home was constructed with two board walls filled with mud in between. The buildings on the property have been razed by new owners, but there are a few log outbuildings in the surrounding greasewood.

Below the Clark Elmer Ranch is Desbrough Canyon. Notice how the ledges appear white with a solid brown sandstone topping. This formation continues to the river, rising as the creek drops in elevation. Desbrough Canyon is between the two high points.

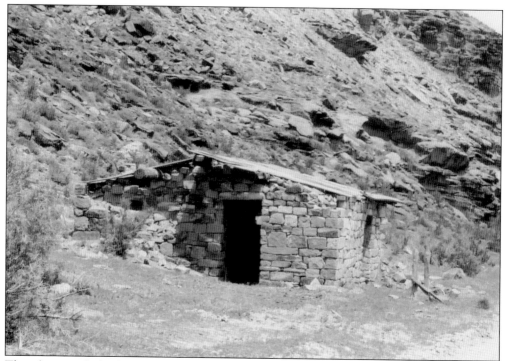

This photograph displays the former home of the homesteader Desbrough, who raised crops on the land. His corrals still stand, as seen below. This structure was eventually bought out by the Pace Ranch, located lower down the canyon. There are two rock structures, both very wide and double walled.

Pictured here is North Franks Canyon. On page 95, the bench road led to a five-mile ride down a wash—this is where that road joins Nine Mile Canyon. It experiences flash floods, like all the canyons, and a traveler may have to move a few rocks and follow a different course, but it is passable with a four-wheel drive vehicle.

This canyon opposite North Franks is South Franks. It is shallow with a good trail. Some use this trail to get up on Horse Bench to chase wild horses.

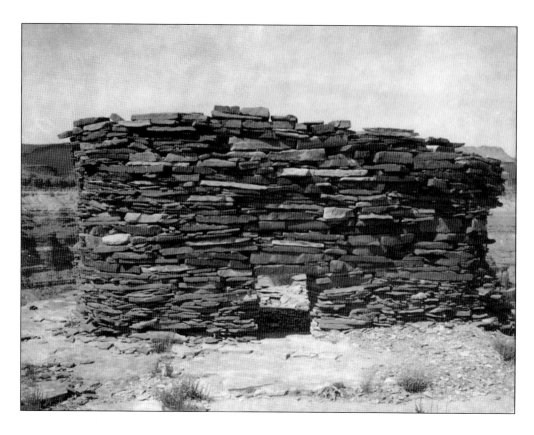

This fort is commonly known as the Nordell Fort. In the image below is the home that was built for Thorald and Lucille Rich when Thorald was managing the properties for the Black Diamond Corporation, owned by Clive Sprouse. They lived on the Pace Ranch just below here until this home was built in 1973. The fort can be seen to the left on the skyline above the house.

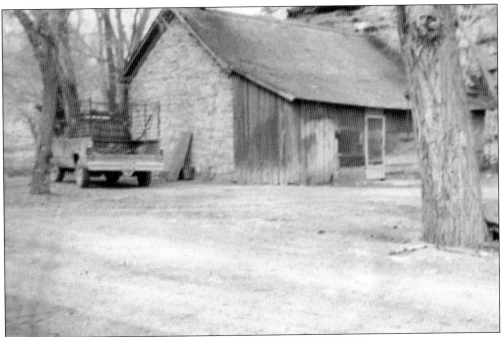

The last ranch in the canyon is known as the Pace Place, named not for the homesteaders but the family who lived there the longest period of time. The Pace family hired Dave Nordell in 1937 to manage the ranch. Nordell spent a lot of time hunting prehistoric artifacts. In hopes of receiving some of his massive collection, the archaeologists from the local museum named the large fort after him. Nordell sold out his shares of the Pace Ranch and left the canyon due to health problems in 1957.

This winter scene shows the Pace Rock House in the background, a log bunkhouse on the left, and a bunkhouse made of lumber on the right. The Rock House had walls that were two feet thick and a screen wire porch that ran the length of the home.

119

A spring from under the ledge inspired the homesteader to put up a rock wall with a door, allowing milk products to keep cool in the springhouse.

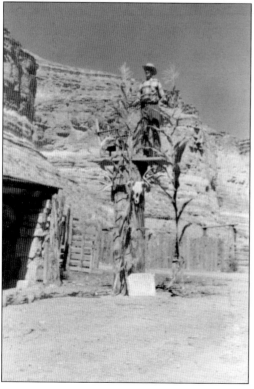

Dave Nordell raised silage corn that grew 14.5 feet tall, as shown in this image. Nine Mile contained fertile farmland, yielding substantial agricultural growth for early homesteaders who would use the nutrient-rich floodwater on their fields after the head of the flood, which was full of debris, passed. This mud strengthened the soil.

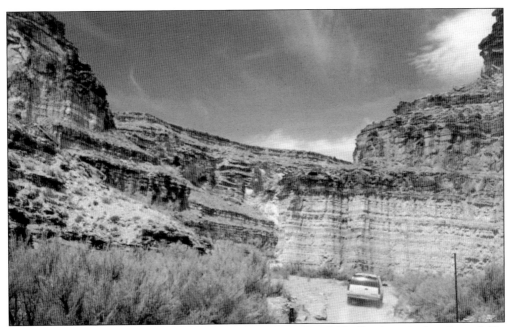

There is a second canyon that a vehicle can drive from Nine Mile Creek to the bench road. Up by the Wrinkles it is called Bulls Canyon. This canyon is located at the bottom of the Pace Place. In this image, a vehicle can be seen entering the canyon.

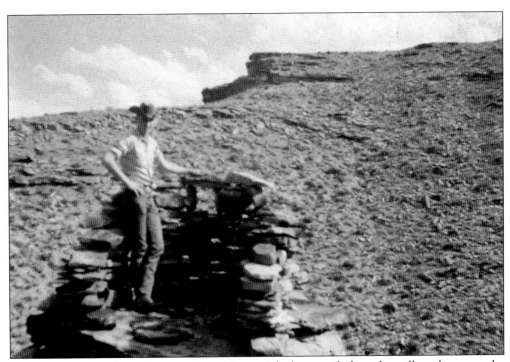

Up Bulls Canyon is the prehistoric Hunter's Point. A little square hole in the wall can be seen—the walls were much, much higher and are still about six feet high on the back side. There were three water seeps, and a square hole faced each one.

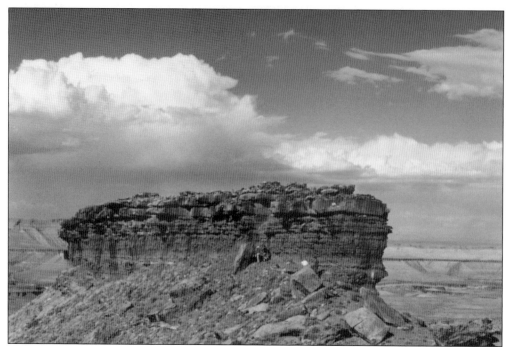

From Bulls, the only accessible trail up the south side is the Wilson Trail, which tops out on Horse Bench. Down Horse Bench on one of the points looking down into Nine Mile Creek is this huge butte with a dry-stacked tower on top. There are many of these types of towers on both sides of the canyon all the way to the river.

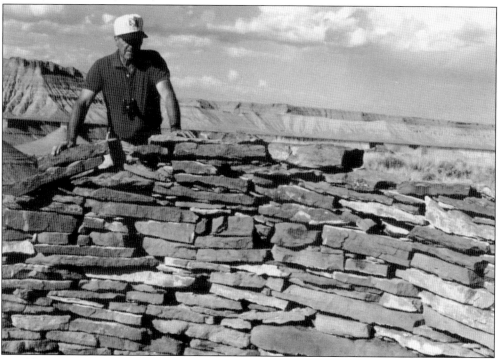

Jerrold Dalton is standing by one tower on the Horse Bench butte.

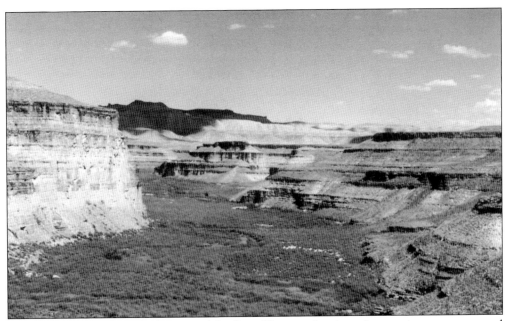

It's about 16 miles from the bottom of the Pace Place to the river. At one time, a wagon road extended to the Green River; it is now impassable.

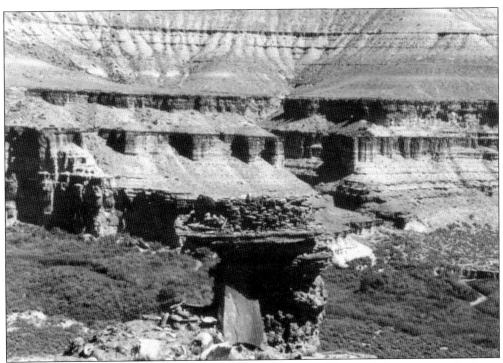

This small tower is on the south side of Nine Mile Canyon. The creek bottom is in the lower right corner of this image.

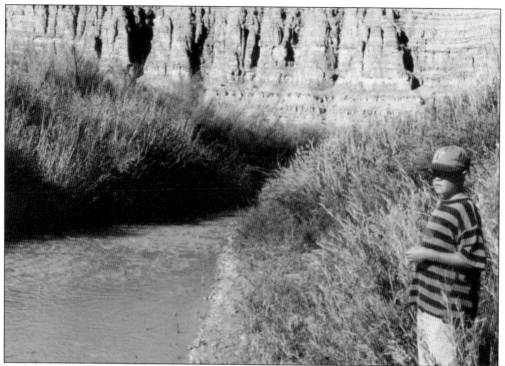

Bo Dalton watches Nine Mile Creek waters as it travels to the Green River one block away.

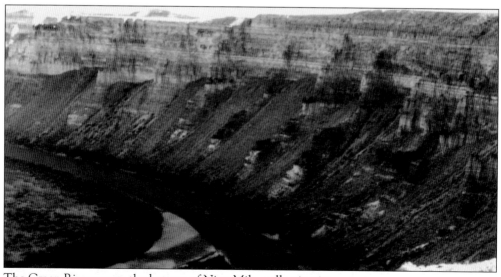

The Green River passes the bottom of Nine Mile, collecting its water.

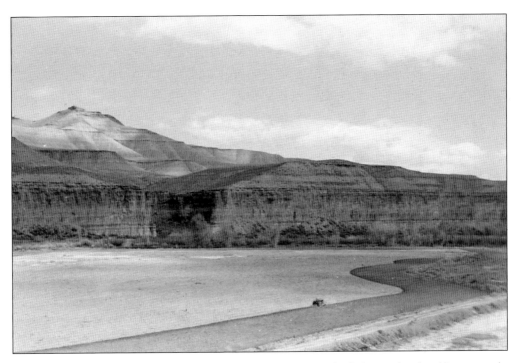

Nutter's Field is on the river bottom. The Green River against the ledge circles this 40-acre patch. Jerrold Dalton was hired by the Nutter's Corporation to plow this field in 1953; it took a week of steady plowing. In the images the light-colored soil is not plowed. The field was not planted or ever used after the plowing.

WHO CARES ABOUT NINE MILE CANYON?

The Nine Mile Canyon Settlers Association was organized in 2004 by Norma R. Dalton, sister Evelyn R. Oldham, brothers Charles C. "Bus" Rich and R. Kirt Rich, and their spouses and children. Several of our ancestors homesteaded in Nine Mile Canyon. The Algers, Houskeepers, and Riches broke and cleared lands and raised their families here. We collected our family histories and those of early settlers and their families. They have been printed in journals and newsletters. We expect to continue to research and tell stories about Nine Mile families and their posterity. We welcome families and people interested in the canyon to share our adventures.

MISSION STATEMENT

To collect, record, preserve and share histories and experiences for the education and enjoyment of all who are interested in Nine Mile Canyon

CONTACT

Nine Mile Canyon Settlers Association (NMCSA)
24 Airlane Drive, Clearfield, UT 84015
nenedalton@yahoo.com

WE CARE!

NMCSA board members pictured are, from left to right, (front row) Kirt Rich, Charles "Bus" Rich, Jenny Christensen, Norma Dalton, Evelyn Oldham, and Lorena Thornton; (second row) Brandon Rich, Tory Oldham, Alene Dalton, and Jerry Thornton.

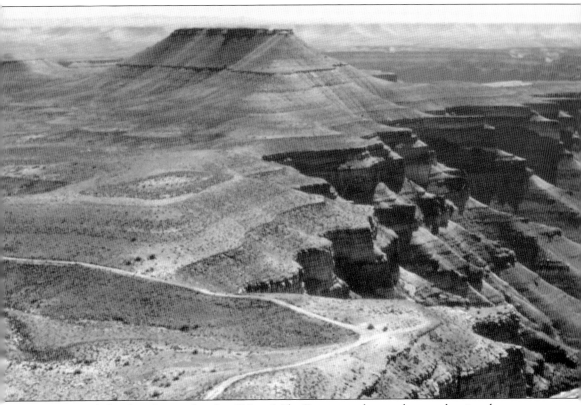

Horse Bench borders the south side of Nine Mile Canyon and runs clear to the river bottom. Green River can be seen on the far right at the base of the darker rims. Notice the white line of the road as it travels over the end of Horse Bench. Standing anywhere on Horse Bench, one can look straight north over Nine Mile Canyon and see the Wrinkles. This completes our journey of Nine Mile Canyon. It began at the summit and followed the creek to Green River.

The lives of Nine Mile settlers were filled with adventure and hard work. One hundred years ago, the climate was wetter. Snow filled the high country, and rain storms caused the desert lands to be covered with vegetation. Because of this wet climate, Nine Mile Creek always ran a good stream, enabling the cultivation of hundreds of acres. My grandfather Theodore Housekeeper grazed his herd of sheep on Horse Bench. Each day, he had to take the sheep down the Wilson Trail to water in Nine Mile Creek. The round trip was three miles.

I was born in 1933, when snow was often two feet deep at the Alger Ranch in the winter. Nowadays, a few inches of snow is an event. The climate has changed, but the skies are still filled with stars at night.

DISCOVER THOUSANDS OF LOCAL HISTORY BOOKS
FEATURING MILLIONS OF VINTAGE IMAGES

Arcadia Publishing, the leading local history publisher in the United States, is committed to making history accessible and meaningful through publishing books that celebrate and preserve the heritage of America's people and places.

Find more books like this at
www.arcadiapublishing.com

Search for your hometown history, your old stomping grounds, and even your favorite sports team.

Consistent with our mission to preserve history on a local level, this book was printed in South Carolina on American-made paper and manufactured entirely in the United States. Products carrying the accredited Forest Stewardship Council (FSC) label are printed on 100 percent FSC-certified paper.

MADE IN THE USA